IMAGES
of America

Upper Saucon Township and Coopersburg

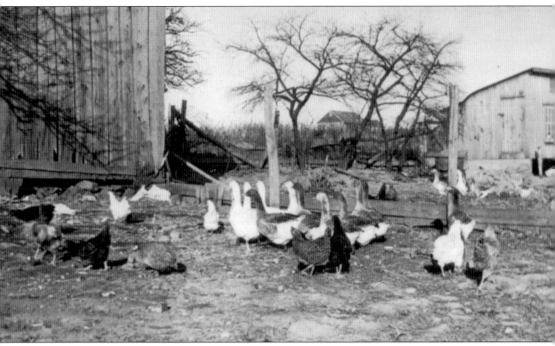

Geese enjoy a feeding on the Urmy farm in Upper Saucon Township near Coopersburg. The wooden shed seen here was attached to a log cabin before both fell into disrepair. The Urmy farm has passed through several generations of the family, and today Brown Swiss cattle still graze the farm that sits beside Route 309 and Passer Road. (Urmy family.)

ON THE COVER: Weekly Sunday school at the St. Paul's Lutheran "Blue" Church began in 1885, though parishioners remembered sporadic classes as early as 1877. Here the primary class of the 1950s is enthusiastic about their lesson. The Sunday school classes held Christmas and Easter concerts as well as other events throughout the year. (Blue Church.)

IMAGES
of America

UPPER SAUCON TOWNSHIP AND COOPERSBURG

Kelly Ann Butterbaugh

ARCADIA
PUBLISHING

Copyright © 2010 by Kelly Ann Butterbaugh
ISBN 978-0-7385-7229-1

Published by Arcadia Publishing
Charleston SC, Chicago IL, Portsmouth NH, San Francisco CA

Printed in the United States of America

Library of Congress Control Number: 2009932160

For all general information contact Arcadia Publishing at:
Telephone 843-853-2070
Fax 843-853-0044
E-mail sales@arcadiapublishing.com
For customer service and orders:
Toll-Free 1-888-313-2665

Visit us on the Internet at www.arcadiapublishing.com

*To my son, Christopher, and my husband, Robert,
you are my future, my present, and my past.*

CONTENTS

ACKNOWLEDGMENTS

Without the help of the Coopersburg Historical Society, this project could not have been completed. Thanks to all involved in the historical society for preserving artifacts, photographs, and information about Upper Saucon Township and Coopersburg—a treasure trove of historical findings tucked away in a few small rooms. Special thanks to Cliff Benner for his additional research and review. Unless otherwise noted, all images appearing in this book were enthusiastically provided by the Coopersburg Historical Society.

Thank you to Cliff Benner and Ted Zapach for contacting countless sources and arranging meetings with them. They consistently pointed me in the right direction for tracking down great photographs, and I am grateful to have worked with them.

Thank you to those who contributed photographs: Mayo Lanning, Pastor Mark Swanson and the St. Paul's Lutheran "Blue" Church congregation, Jeff Donat, Ralph and Jean Urmy, Donald Bassler, Robert Yeager, Cliff and Lorraine Benner, Ted Zapach, the Limeport Stadium Organization, the Sisters of the Carmelite in Lanark, Sam Hafner and the Liberty Bell Elementary School, and Pastor Rick Paashaus and the Calvary Bible Fellowship congregation.

Thanks to those who contributed information about the township: Cliff and Lorraine Benner, Mayo Lanning, Pastor Mark Swanson, Jeff Donat, Ralph and Jean Urmy, Gary Urmy, Pastor Rick Paashaus, Ted Zapach, Thomas Beil and the Upper Saucon Township management, Donald Bassler, the Sisters of the Carmelite in Lanark, Gretel Ruppert, Joseph and Peg Volk, Thomas Fulton and the Limeport Stadium Organization, and the Southern Lehigh Public Library.

My very special thanks go to my family for their support and encouragement during this project. Thank you to my husband, Robert, and my son, Christopher, for helping me to organize my research and for helping me to find the time to do what I love. Enjoy the history of our home.

INTRODUCTION

Why study history? Time and time again historians are asked this question. It is an interesting question with an even more interesting answer.

History provides people with a sense of understanding. Knowledge of history allows people to make informed decisions about the present. Those who support and work with the Coopersburg Historical Society help to preserve the history of the area around the borough, especially since there is no active historical society in Upper Saucon Township. The members of this society are helping to educate a new generation of Americans about the vital lessons of the past. That is why they study history.

Others study history because it reflects the changes of the area being studied. The pictures on these pages will do that. Pictures stand as a testimony to the changing times in the borough and township. Some like to think and hope that the area never changes, but it does regardless.

The Upper Saucon area has undergone great changes since it was first settled by Germans in the early 1700s. These settlers set down buildings and dirt roads in places where the Lenni Lenape tribes stayed while they traveled across the area. These tribes named the area Saukunk from their word *sa-ku-wit*, which they used to describe their temporary camp at the mouth of the Saucon Creek.

Today Upper Saucon Township lies in Lehigh County. Originally Upper and Lower Saucon Townships were one and were a part of Bucks County known as Old Saucon Township. This original township was organized by the Pennsylvania Germans in 1742. It was not until 1743 that Old Saucon Township was split into the two separate townships. More changes occurred when county lines were changed in 1752 and the two townships that had been in Bucks County were now in Northampton County. When Lehigh County was formed in 1812, the two townships became distinctly different from one another. On March 6, 1812, the new Lehigh County took claim of Upper Saucon Township, while Lower Saucon Township remained in Northampton County.

However, changing political lines do not change a community; community lines are not as clearly drawn. The divide between the Upper Saucon and Lower Milford Townships runs through the area of Limeport, but the town of Limeport is a communal part of Upper Saucon Township. Later, Coopersburg became its own borough, but it is still a part of the Upper Saucon community.

Many other people study history because they are interested in everything that was yesterday. The pictures on these pages will serve as a record of where Coopersburg and Upper Saucon Township stood at set places in time. Five, 10, or 20 years from now, people will look back on these pages and see how the people looked and what they were doing. Those future readers will smile and laugh and wonder why people wore such ridiculous fashions and funny hairstyles. By then, the town and township will have changed again. By then there will be new faces to photograph, new names to learn, new houses to write about, and new stories to tell.

Today there is a story to tell. It is the story of entrepreneurs like Samuel Kern, Jacob Ueberroth, and William Urmy, who opened their businesses, their quarries, and their delivery routes. It is the

story of farmers like the Coopers who worked the land and managed their livestock. It is the story of the township and its burgeoning borough. It is the story of several small rural towns working together to form a community known as Upper Saucon Township.

Upper Saucon Township has distinctly named areas—Limeport, Standard, Lanark, Blue Church, Locust Valley, Colesville, Friedensville, Center Valley, Coopersburg, and Spring Valley—all reflecting their individual histories. Limeport was named after the limestone it quarried, the Blue Church area took its name from its well known and uniquely colored Lutheran church, and Spring Valley earned its moniker from its plethora of natural springs.

Other towns saw significant change, making industrial and communal advancements from their agricultural roots. Friedensville was a small farming area in the eastern end of the township until zinc was found on the Hartman farm. From that moment onward, Friedensville became an important zinc mining community with a large housing development built specifically for those who worked in the mines. The mining that occurred there from 1853 through the 1980s affected the entire Saucon Valley while it was in operation. Water tables rose and fell in accordance with the mines' pumping, and land stability was brought into question in areas above the mines. Today the mines are quiet, and the area is developing into corporate offices and retail spaces, continually changing.

Through all of the township's growth, the town of Coopersburg saw the most change. Originally named Frysburg in honor of Judge Joseph Fry, the town was small but had great potential. This potential was tapped by George Bachman, who opened a tavern in town. On June 25, 1832, the town was renamed Coopersburg in honor of the entrepreneurial spirit of Judge Peter Cooper. Cooper became an influential leader in the formation and early growth of the town. Also seeing the possibilities of the town was Milton S. Gabriel, who opened his hosiery mill on Main Street. A. O. Gehman set up a successful storefront along Main Street, and post offices and schools followed the success. All of this progress created a problem for the people of town. They needed amenities that the township could not provide. There was no need in other parts of the township for sidewalks, paved streets, streetlights, and public water, yet Coopersburg had these needs. This led to the petition to incorporate the Coopersburg Borough to meet the demanding needs of the growing town. Borough status was granted on December 2, 1879, and Coopersburg became its own entity within the limits of Upper Saucon Township.

As the population of the township continued to grow and change, school officials saw a need to make more changes. Those with insight saw that by combining the Upper Saucon schools with Coopersburg's and Lower Milford's schools, a stronger school system could be created with the greatest number of resources for the area's children. So was born the Southern Lehigh School District, a vital communal resource that unites three separate communities.

So, why study history? There are so many reasons, and preservation may be one of them. This book will be at work teaching history long after its writers are gone. It is with hope that the reader 20, 50, and even 100 years from now will know the people of Coopersburg and Upper Saucon Township. These few pages can never possibly tell the whole story of what roads the residents have traveled, what burdens they have borne, and what joys they have celebrated. It stands merely as a record of the people.

Look over these pages, now and in the future, and see the faces of Coopersburg and Upper Saucon Township in this place and time to see what changes have been made and what changes are yet to be made.

—Clifford W. Benner
President of the Coopersburg Historical Society,
with Kelly Ann Butterbaugh

One

THE CROSSROADS

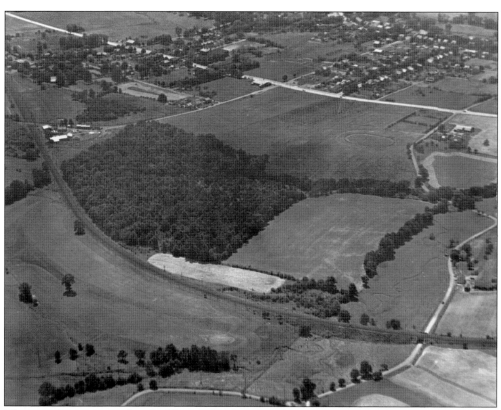

This aerial view was taken by Harvey Bassler while he was learning to fly an airplane. Seen cutting through the farms of the township are the railroad tracks that serviced Coopersburg and Center Valley. The area was often called "the crossroads" because milk traveled south from the area towards Philadelphia while iron and limestone was shipped east across the township from Limeport to Bingen.

The Saucon Creek is the main artery of the township. The creek is named after the tribal town Saukunk, which was not a permanent settlement but a stopping place along the creek. The Lenni Lenape named their town after the word *sa-ku-wit*, which means "mouth of a creek." William Penn purchased the land from the tribe, though they didn't understand the terms of the purchase.

This portion of the Saucon Creek no longer exists, demonstrating how the path of the creek has changed since the first settlements. During the operation of the Friedensville mines, the water table dropped severely enough to dry up branches of the creek—branches that never returned as the table rose. Development also rerouted the creek through culverts and under roads. (Jeff Donat.)

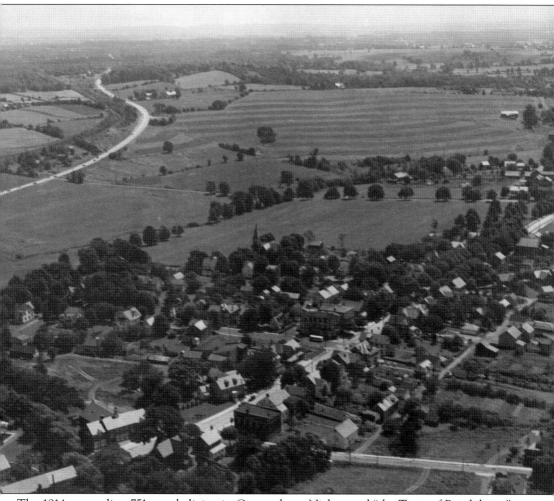

The 1914 census lists 751 people living in Coopersburg. Nicknamed "the Town of Possibilities," Coopersburg offered many options for its residents, such as schooling through the 10th grade, community organizations, and a variety of industries. This aerial photograph taken in the 1930s shows landmark buildings lining Main Street. The Blu Dov pool is at the bottom left, beside the new town hall. In the center of the photograph, the spire of the St. John Church can be seen surrounded by fields. Architect Genaah Jordan built his home next door to the church along Thomas Street. At the top of the photograph, the new "superhighway" State Route 309 can be seen winding its way through the farms. (Clifford Benner.)

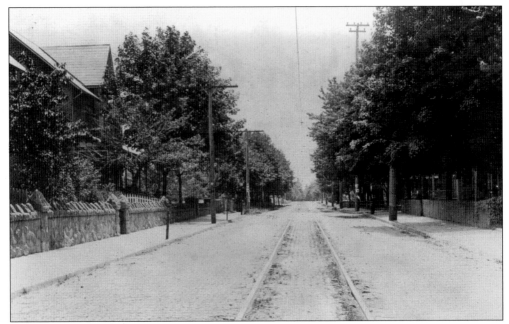

When a dirt road became Main Street, hand-picked stones and bricks were laid as the base. The stones were picked from the fields by Alfred Keiss and his son Paul after they made their early-morning ice deliveries. These paved roads allowed for heavier wagons to pass without problems and later for the trolley cars.

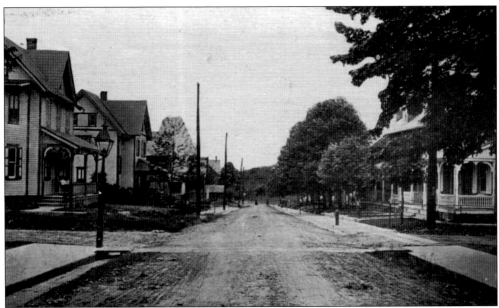

This early view of Fairview Street looking east from Main Street shows Coopersburg's size before it outgrew its original territorial mile. Fairview Street grew to include the Urmy store as well as a saddlery. Notice the unpaved road that grew muddy in the rain and the lamppost that was lit nightly by the lamplighters.

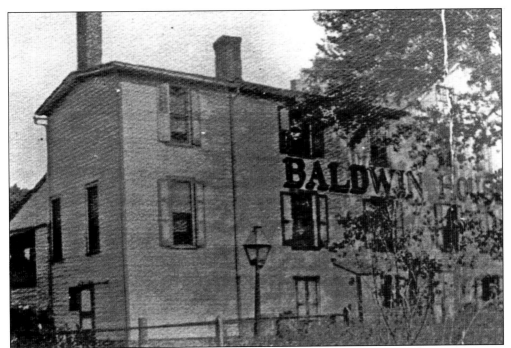

The Baldwin House is a Coopersburg tavern that withstood the test of time. Still present along Station Avenue east of Route 309, the Baldwin House was built in 1856 and was named after the train that took passengers from Bethlehem to Philadelphia. It relied on the train passengers for its business, offering services to meet their traveling needs. In 1900, it passed into the hands of the Kemmerer family, where it remained for several generations.

The first tavern and non-agricultural business in Coopersburg was Der Siebenstern, built by George Bachman between 1745 and 1750 and later purchased by Joseph Fry. In German its name means "seven stars." This stone stable was built to accommodate the tenants' animals, possibly 30 to 40 teams of horses. Today's town hall stands on the barn's original site.

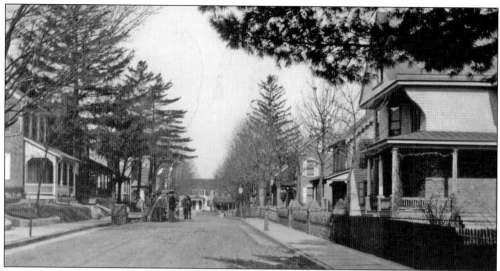

A road crew is seen making repairs to Station Avenue near Kenneth Kern's house. The Kern family has a long history in transportation. Samuel Y. Kern operated a carriage manufacturer in Coopersburg. His son Harvey Kern was the first authorized Ford dealer in the area, and his grandson Kenneth Kern was known nationwide as a Franklin mechanic. Kenneth's garage was in the rear of the two-story white home on the right. (Donald Bassler.)

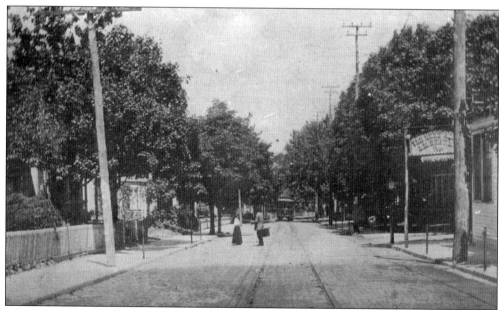

The first two streets in Coopersburg were Main Street and Cunningham Street, though they began as dirt roads that caught wagons in the ruts on rainy days. After the railroad was established, Cunningham Street became Station Avenue. This photograph of Main Street shows the view just beyond Station Avenue in the early 1900s. To the right is the sign for the Van Ness House.

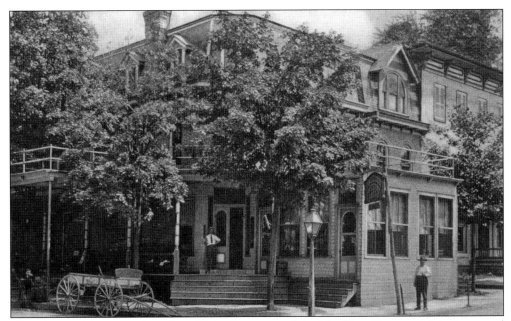

The advent of the trolley line along Main Street caused the Van Ness House at Main Street and Station Avenue to convert the first floor porch into a waiting room for the trolley stop. Time saw the building become a hotel, a store, and an ice cream parlor. When busses replaced the trolleys, the waiting room was adapted for the nearby bus stop.

The Van Ness House was Coopersburg's third hotel. It was built in 1883 by pharmacist Dr. Aaron Gery and was named after his favorite hotel in Vermont. The Van Ness House operated as a pharmacy and a boardinghouse at that time. This photograph shows the change in the building over the years. Today Dr. Douglas Shoenberger is in the process of completing a restoration of the building. (Donald Bassler.)

Coopersburg slowly welcomed indoor plumbing when it added water mains through town in 1902. These homes on Main Street could tap into the town water, which was fed by natural springs. They would pay based on the number of faucets in each home. In droughts, the water supply fell, and low water pressure was a problem. Until 1948, the town's water supply was shut off from 6:00 p.m. until 6:00 a.m. to conserve water.

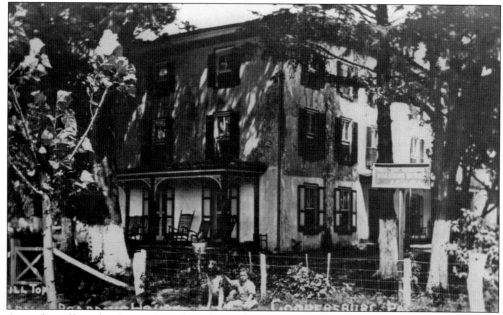

A number of boardinghouses have been located on Hilltop Road at the edge of the township near the North Pennsylvania Railroad route. Many township taverns claim to have been speakeasies during Prohibition, and remnants of distilleries were found on properties along Vera Cruz Road. One such location, today's Inn of the Unicorn, even claimed to have an underground tunnel connecting it to the Friedensville mine shaft.

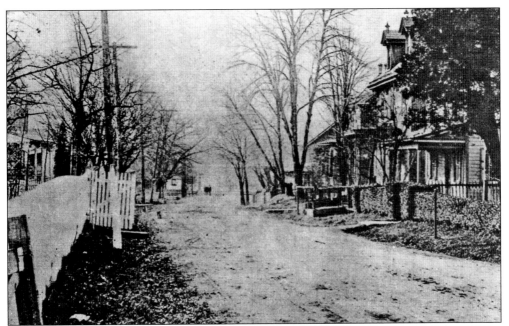

Looking west from Railroad Avenue in Center Valley (above), the area around the Center Valley Station was known as Milk Town. In the 1870s, 2.5 million gallons of milk rode the railroad each year from the area into Philadelphia. Another view of Center Valley looks east on Railroad Avenue from the Centennial Bridge (below). The arching stone bridge was built by Center Valley men with Center Valley stone. Called "a great feat of engineering" by historian Albert Ohl, the bridge was commissioned on September 13, 1875, to be built by Enos Erdman for $1,200. With the help of blacksmith and wheelwright Jonathan Swartz, the bridge was built from stone purchased from Henry Sell's quarry. The bridge was repaired in 1918 and again in 1933 before a crack split the supporting arches in 1992, causing the bridge to be closed. (Both, Clifford Benner.)

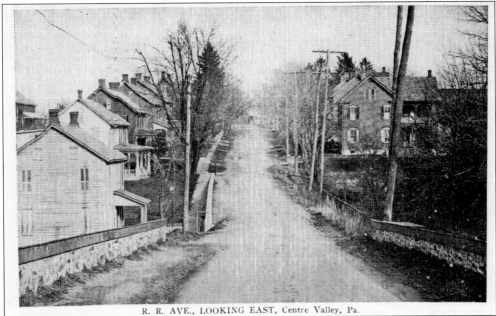

R. R. AVE., LOOKING EAST, Centre Valley, Pa.

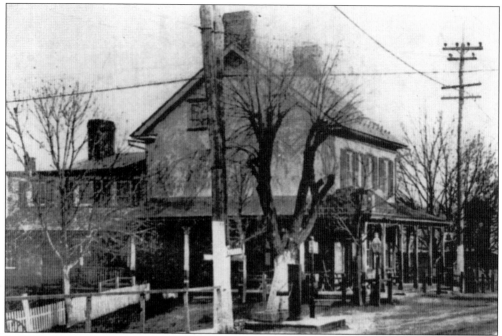

In 1848, Center Valley had one store, a hotel, and a 60-acre farm. By 1862, it had added a post office, a blacksmith, and a shoemaker. That first hotel was the Center Valley Hotel, later known as the Grand Central Hotel, built in 1831 and operated by James Wilt. Automobiles and the decline of the railroad led to the hotel's closing in the 1920s and its demolition in 1974.

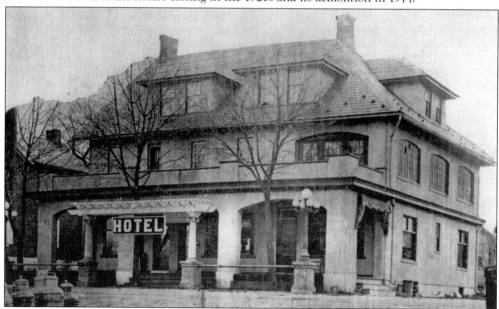

Built in 1878 by Jonathan Swartz, the Windsor hotel has stood in Center Valley long enough to earn the title of the longest-standing hotel. The building started as the Weaver brothers' wheelwright shop. It was not until automobiles replaced horse-drawn carriages that the building was converted into the tavern that it remains today. (Clifford Benner, courtesy of the Richard Weaver estate.)

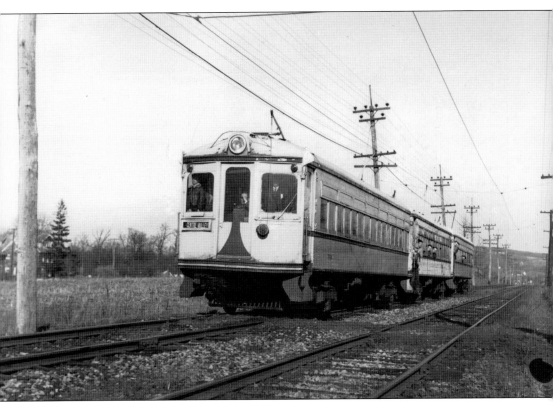

Anxious to be home, students prepare to exit trolley car No. 702 on April 15, 1951, along the Center Valley school siding. Between 1928 and 1931, one trolley was assigned to complete the school run between Center Valley and Allentown High School during the school year. The trolley station for Center Valley was located on Windy Heights, and children enjoyed sledding on the hill beside the tracks. This trolley was one of the last to make the trip into Center Valley, as the trolley service came to an end on Thursday, September 6, 1951. On January 22, 1951, Bert Lichtenwalter wrote a letter informing residents of the planned abandonment of the Liberty Bell route. (Kelly Ann Butterbaugh.)

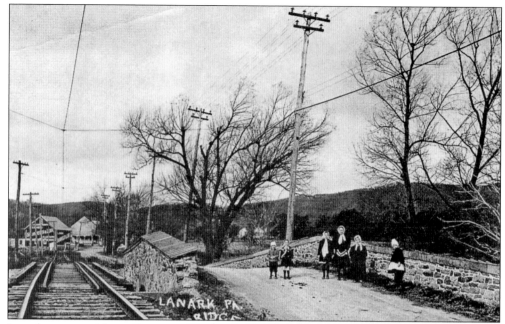

Lanark was named for a village near Glasgow, Scotland, and Lanark Road, seen here, was established in 1750 as the Great Philadelphia Road. This stone bridge spans the Saucon Creek beside the Lichtenwalner farm. The Liberty Bell trolley tracks sit parallel to Lanark Road. The white building in the distance is Heller's Tavern, later Alton Knerr's store, with its barn seen in front of it. This barn is now a double home. (Clifford Benner, courtesy of the Richard Weaver estate.)

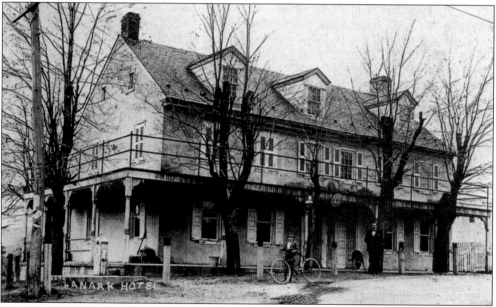

Heller's Tavern in Lanark went by many names since it opened in 1800. In this photograph, it is the Lanark Hotel, called Trumbauer's hotel while it was owned by Bill Trumbauer in 1914. Some time in the 1940s, Alton Knerr purchased the building, and it became Alton Knerr's store, not to be confused with J. D. Knerr's store, found in Coopersburg. Evidence shows that an even older building stood on the foundation.

LEHIGH VALLEY TRANSIT COMPANY

PHILADELPHIA DIVISION - TIME TABLE No. 35
South Bound WEEKDAYS

TRAIN NOS. STATIONS	Mileage	2	4	8	500	300	198	502
		A.M.	A.M.	A.M.	A.M.	A.M.	A.M.	A.M.
ALLENTOWN						6.05	6.10	6.35
EMMAUS JCT.	2.30			4.40	5.43	6.14	6.25	6.44
LEHIGH	4.90			4.47	5.49	6.20	6.32	6.50
SCHOOL N / S	6.85 / 7.34			4.53	3 5.55	6.25	6.37	5 6.55
CENTER VALLEY	7.50			4.54	5.56	6.26	6.38	6.56
COOPERSBURG	8.76			4.58	5.59	6.29	6.42	6.59
COOPERS N / S	9.85 / 10.35			5.02	6.02	6.32	5-502 6.46	199 7.02
WOOD	12.28			5.06	6.05	6.35		7.05
QUAKERTOWN	14.32			5.11	6.09	5 6.39		7.09
RED LION	14.60			5.12	6.11	6.42		7.12
LOCUST	15.32			5.15	6.15	6.46		7.16
RIDGE	19.00			3 5.24	5 6.24	6.55		7 7.25
PERKASIE	20.58			5.35	6.28	6.59		7.29
SELLERS N / S	21.52 / 21.93			5.40	6.32	7.02		7.32
NACE	24.83			5.49	6.39	7 7.09		7.39
CAR BARN Y	25.04	4.50	5.15	5.50	6.40	7.10		7.40
SOUDERTON	25.73	4.55	5.20	5.55	6.45	7.15		7.45
GEHMAN N / S	27.03 / 27.48	4.58	5.24	5 6.00	6.48	7.18		7.48
HATFIELD	28.16	5.00	5.27	6.02	6.50	7.20		7.50
ANGLE	29.22	5.03	5.30	6.04	6.52	7.22		7.52
COUTER	30.31	5.07	5.33	6.07	7 6.55	7.25		11 7.55
LANSDALE	31.35	5.12	5.39	6.12	7.00	7.30		8.00
BROAD	31.75 / 33.08	5.15		6.15	7.03	7.33		8.03
ACORN	35.34	5.20		6.20	7.08	11 7.38		301 8.08
WASH. SQUARE	38.29	5.26		6.25	7.14	7.44		8.14
BRUSH	38.85 / 39.77	5.29		7 6.30	7.17	7.47		8.17
MARSHALL	41.10	5.34		6.36	11 7.23	301 7.53		503 8.23
RINK	41.44	5.36		6.38	7.25	7.55		8.25
NORRISTOWN	41.78	5.40		6.42	7.29	7.59		8.29
		A.M.	A.M.	A.M.	A.M.	A.M.	A.M.	A.M.
TRAIN NOS.	Mileage	2	4	8	500	300	198	502

This trolley transit timetable shows several stops in the township, including a school trolley that delivered students to the nearby high schools. Students living near the trolley attended Allentown High School or Central Catholic High School. Those who lived near the North Pennsylvania Railroad trains took them to Liberty High School if they chose to attend grades 11 and 12. Allentown-to-Coopersburg trolley service through the Lehigh Valley Transit Company began on December 19, 1901. It was renamed the Liberty Bell route on December 1, 1907, and it provided door-to-door service from 1908 through 1951, when it was replaced with public busses. (Clifford Benner.)

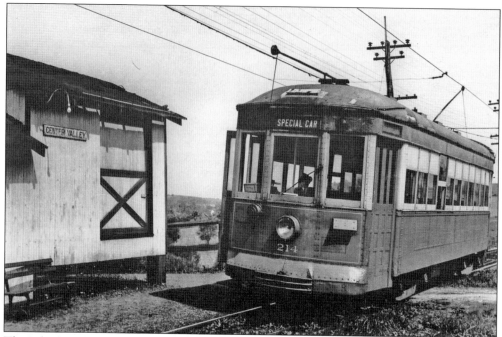

The Lehigh Valley Traction Company established the Liberty Bell route through Upper Saucon Township and Coopersburg. Parts of Center Valley were serviced by the Bethlehem Transit trolleys. Here a trolley stops at the Center Valley station. The Liberty Bell route was named after the famous bell's path through the township on its way to Allentown in 1776, when it was hidden from the British invading Philadelphia.

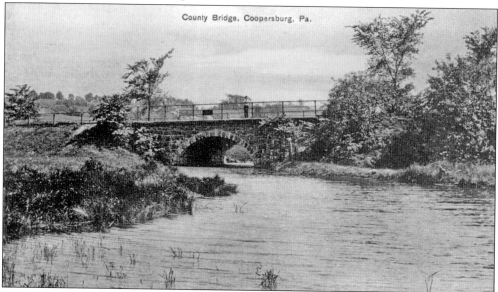

Station Avenue, formerly Cunningham Street, served as a connection between the Pennsylvania and Reading train station in Coopersburg and the farms to the east of the town that brought their goods to the station. A wooden bridge was built over the Saucon Creek at Station Avenue to connect the town to the other side. That bridge was replaced in 1885 with this stone bridge, which still stands.

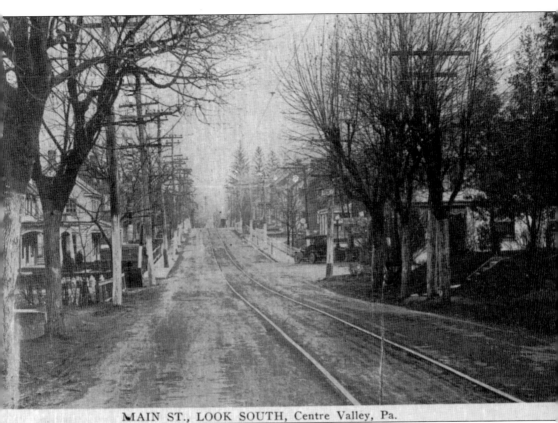

MAIN ST., LOOK SOUTH, Centre Valley, Pa.

The view looking southward on Main Street in Center Valley during 1915 is very different than the view today. Today, the northbound lanes of Route 309 cover the original dirt road of 1915. Long gone are the trolley tracks, which were abandoned in 1951. The Hotel Windsor sits on the right, hidden by the trees lining the street. A patron's car is parked alongside the road. The sidewalks lining the road are now gone, but many of the same homes still line the street, and the tavern still welcomes guests. A few of the homes even have outhouses, now only ornamental, in their backyards just as they did when this photograph was taken. (Kelly Ann Butterbaugh.)

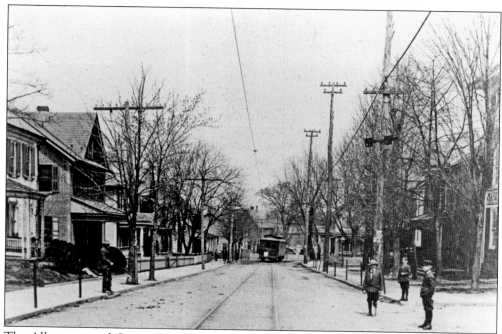

The Allentown and Coopersburg turnpike opened in 1875, following the Old Philadelphia Road. Toll gates dotted the area, charging heavy tolls. One was at Passer Road and Main Street in Coopersburg. In 1900, travelers would have continued down Main Street, seen here looking north. Another toll was in Center Valley, and a separate toll was collected on Limeport Pike near West Saucon Valley Road. In 1910, the road became public.

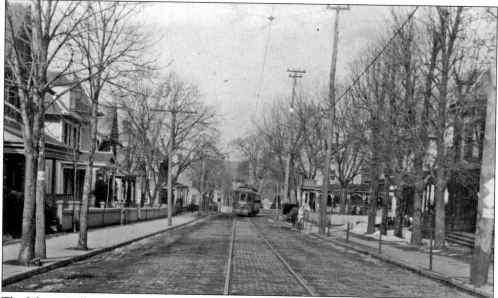

The Liberty Bell trolley route ran along Main Street in Coopersburg starting on December 19, 1901. It followed the path of the Old Bethlehem Pike, an expensive toll road. However, the trolleys cut back on the toll charges and became a popular form of transit. The Liberty Bell route continued on Main Street until 1925, when it was moved west to make room for automobile traffic on the street.

The highest geographical point along the Reading Railroad route between Hellertown and Philadelphia is known as Horseshoe Bend or Bunker Hill near Hilltop just outside Coopersburg's territorial mile. On a clear day, visitors claim to see as far as Boyertown. Upon incorporation, Coopersburg quickly began to thrive as a separate borough, and it rapidly spread beyond its original territory of one square mile.

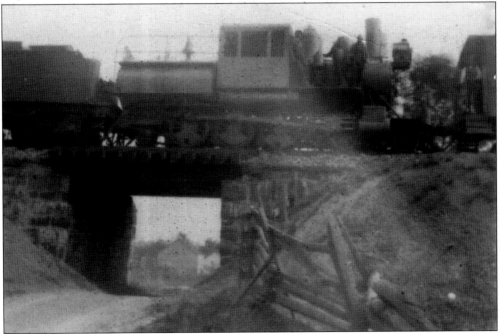

When the North Pennsylvania Railroad opened in 1856, it immediately ignited industry in the area. This train passes through Coopersburg. In 1876, there were 58 operating locomotives on the route, and they carried 1,310,000 passengers in 1878. On May 15, 1879, the North Pennsylvania Railroad merged with the Reading Railroad to make the Pennsylvania and Reading Railroad (P&R) that then serviced the area.

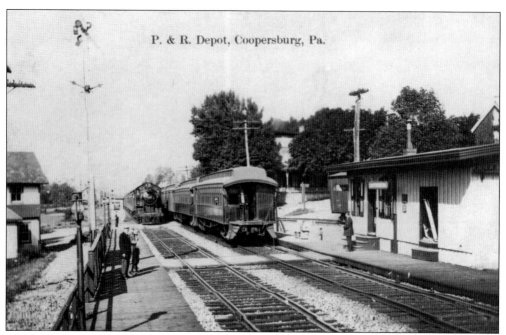

The first passenger train of the North Pennsylvania Railroad passed through Coopersburg on December 25, 1856, and grew from there. Behind the P&R station stood Trumbauer's store, where farmers deposited full milk jugs, cages of chickens, and other goods for rail pickup at 6:00 a.m. In the afternoon, the train returned the empty jugs to the store for refilling the next day.

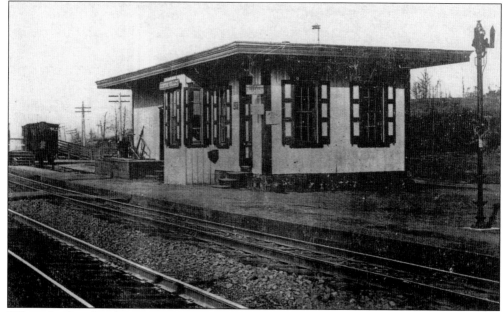

When the first freight train passed through Center Valley on January 1, 1856, there was no station like the one in this photograph. Center Valley petitioned and received a freight depot and eventually a passenger station and telegraph operator. The passenger station closed in 1942, while the freight station operated until the mid-1980s. ConRail owned the North Pennsylvania Railroad at that time. (Clifford Benner.)

Two

DAILY LIFE

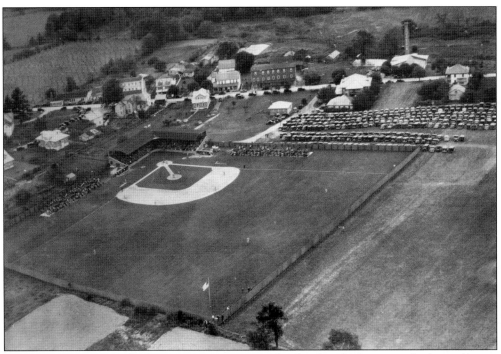

Though it lies just outside the Upper Saucon Township border, the Limeport Stadium plays an important role in the community. The stadium boasts the deepest center field of any professional or amateur ballpark in the nation, 485 feet from home plate. During construction, a persistent boulder caused the deeply inclining field. Only one player, Alex Sabo, ever hit a ball past it. (Limeport Stadium.)

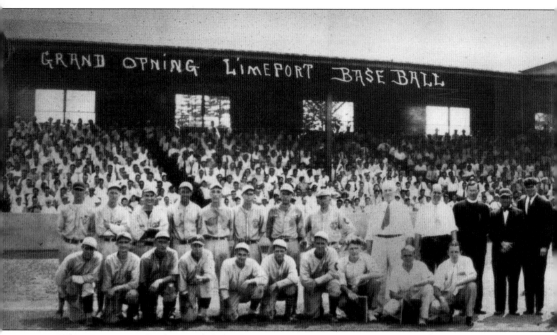

When Limeport Stadium celebrated its opening day on July 30, 1933, more than 4,000 people came to see the Limeport Milkmen play. Today's visitors can sit in the green, fold-down seats that were installed the night before the opening day. The stadium was modeled after Philadelphia's

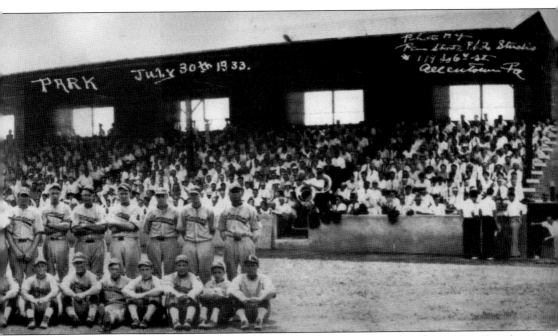

Connie Mack Stadium, and it was declared that no professional games should ever be played within its fence. (Limeport Stadium.)

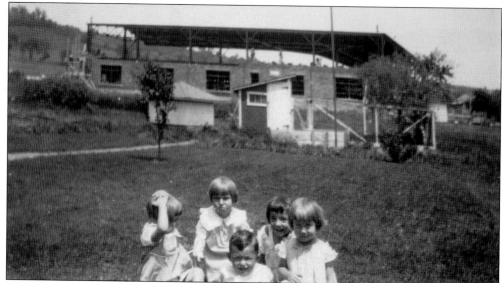

The brick base and metal trusses of Limeport Stadium are under construction here. To meet the needs of the growing baseball crowd in the township, Howard Fegley built the stadium next to his dairy farm. With only 1,100 seats, the stadium is the home of the Limeport Dodgers and the Limeport Bulls as well as the Southern Lehigh High School team. (Limeport Stadium.)

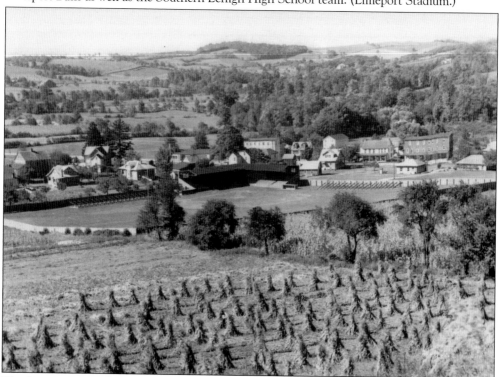

The Limeport area lies partially in Upper Saucon Township and partially in Lower Milford Township. The lime kilns near the town operated from 1850 to 1885, when they shipped the lime to Bingen for use in the steel industry. Looking down on Limeport Stadium, Blue Church Road meets Limeport Pike just behind the stadium. (Limeport Stadium.)

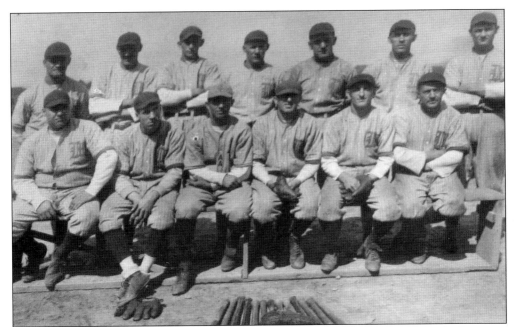

The Limeport Dodgers pose for a team portrait. Howard Fegley's original team was the Limeport Milkmen, who played for the East Penn Baseball League as well as the Limeport Athletic Association. Fegley and his two sons, enjoyed the great American pastime, and many said he built the stadium for his sons as well as for their community. (Limeport Stadium.)

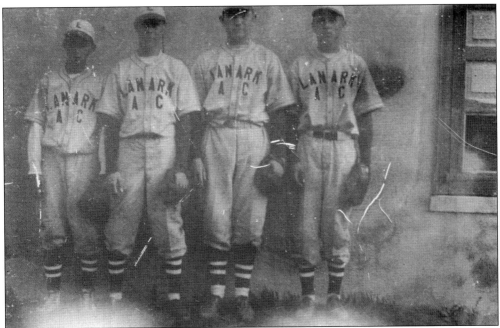

Many small baseball teams in the community once called Limeport Stadium home. Here the 1938 "miracle infield" of the Lanark team poses for a photograph. They are, from left to right, Robby Laub, shortstop; Jimmy Maus, third base; Henry Knerr, second base; and Frank Zotter, first base. (Limeport Stadium.)

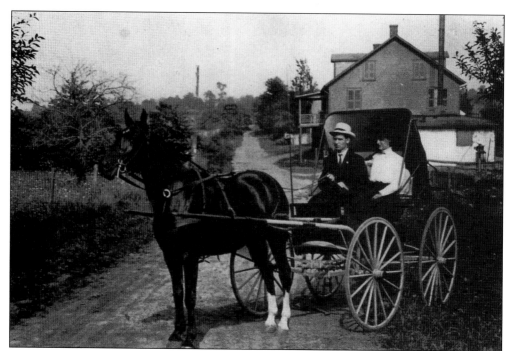

Howard Fegley and his wife stop for a photograph along Limeport Pike. Nicknamed "Lefty," Fegley built Limeport Stadium after establishing himself as local baseball star in the early 1900s. He cofounded the East Penn Baseball League, which lasted from 1932 until 1950 with his Limeport Milkmen, a team that he named after his dairy business. Fegley also founded the Limeport Athletic Association. (Clifford Benner, courtesy of the Richard Weaver estate.)

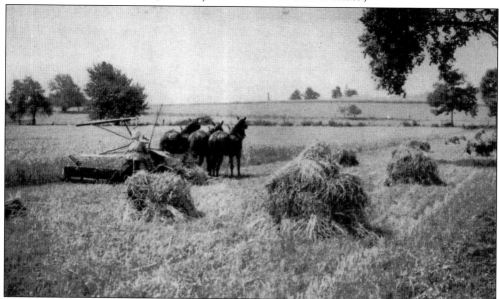

Howard Fegley operated Fegley's Dairy in Limeport. Work on his farm filled his day, but he still found time to play baseball and pass the love onto his sons and his community. Dairy farming was prominent in the township, and Fegley's farm was one of many. Creameries also dotted the area, including two along Limeport Pike.

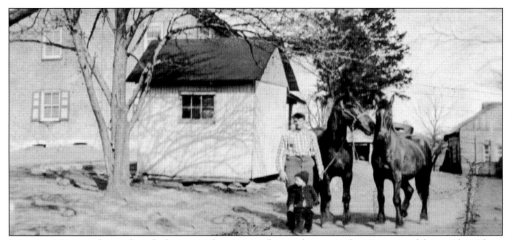

Marvin Urmy takes a break from work to pose for a photograph. Urmy and his wife, Edna, raised four children, Ralph, William, Evelyn, and Lorraine, on their dairy farm in Upper Saucon Township just outside of Coopersburg. Ralph and William went on to care for the family's farm, and their children continue to help them with the land today. (Urmy family.)

Marvin Urmy celebrates his 21st birthday surrounded by family in 1923 on the Urmy farm. Marvin was raised on the farm run by his father, William S. Urmy. William inherited the farm from his father, John Urmy, who gained it from his father, Joseph Urmy. The family can trace their land deed back to the Yoder estate, which purchased the land from William Penn.

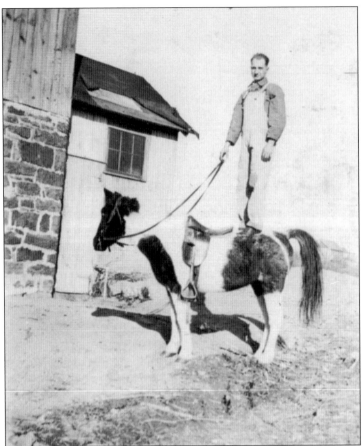

At the Urmy farm, a young Charles Urmy bravely poses on top of one of the horses. Charlie, as well as his brothers, Floyd, Marvin, Barton, and Elmer, helped his father, William, manage the farm land located beside Route 309 today. Charlie was killed when his home on Main Street in Coopersburg burned after the 1973 gas explosion. (Urmy family.)

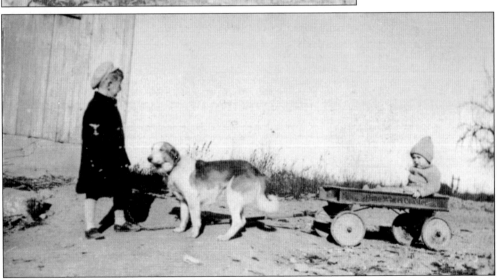

William S. Urmy's grandson, also named William (left), enjoys playing on the farm with Sport, the family dog, and his brother Ralph. Ralph remembers life on the farm filled with quiet moments like these. Often on Sundays, his mother would get out the camera and photograph her children playing in the fields. (Urmy family.)

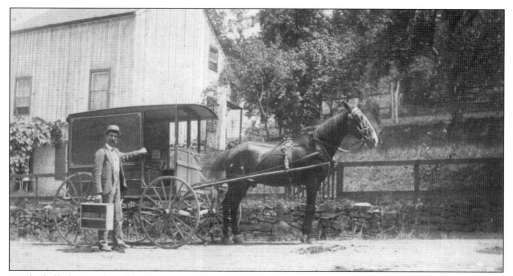

With skills learned at the Newcomer Bakery, William S. Urmy opened a bakery of his own along Fairview Street in Coopersburg. He added a store in 1901 and ended his baking career with his son Floyd and his daughter-in-law Marie's wedding cake in 1932. Another son, Barton, who also worked for Shafer Brothers, managed the store after his father's retirement. This photograph was taken on the Urmy farm in 1904. (Urmy family.)

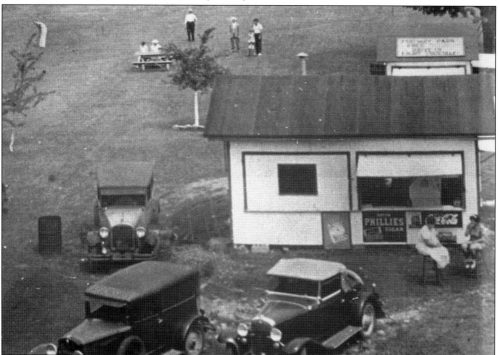

On Independence Day and during other special events, residents would gather at Midway Park for a town picnic. Midway Park, sometimes called Urmy's Grove, was owned by Floyd and Marie Urmy. Visitors accessed the picnic grounds by following a dirt road behind the Saucon Mennonite Church and crossing the creek on wooden planks. The area is now separated from the Urmy farm by Route 309, and it houses a machinery rental business. (Urmy family.)

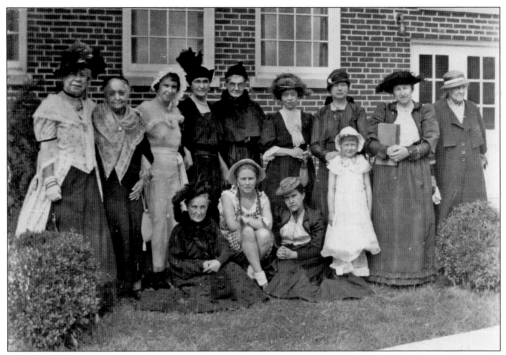

The King's Daughters of the Coopersburg Moravian Church pose after a production. From left to right are (first row) Florence Miller, Sally Gish, Anne Knerr, and Cleora Stauffer; (second row) unidentified, Sally Geisinger, Ruth Geisinger, Mame Young, Agnes Urmy, Helen Landis, Minnie Gehman, Florence Hackman, and unidentified.

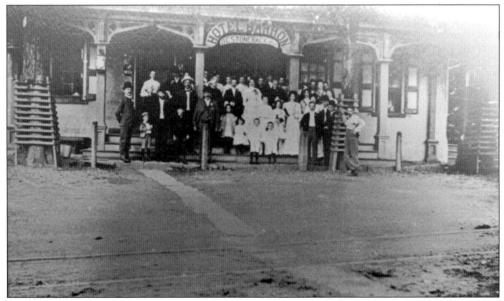

The wedding party of Irwin Ruppert and Ida Weaver pose in front of the Hotel Barron. The hotel operated from 1829 until it was purchased by the Coopersburg Fire Company in 1940 for use as its social hall. At one point it was a stagecoach shop. The wedding party is standing on the porch that was added in 1848.

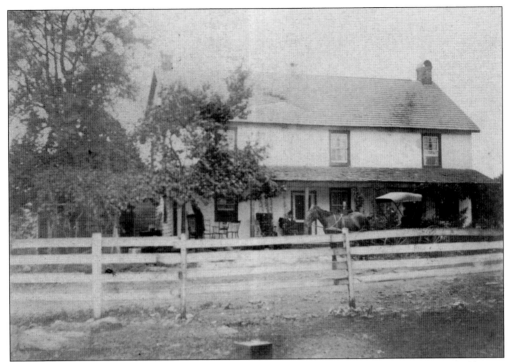

Here is a typical home in the rural Upper Saucon Township. Visitors have arrived by horse and buggy, and the family sits on the front porch, enjoying the rolling hills and farms surrounding them.

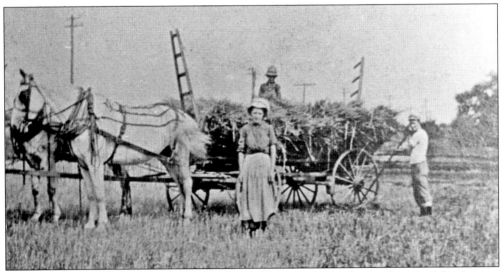

Early harvesting was done by hand, and this full wagon shows the fertile soil of the Saucon Valley. Census reports from 1880 and 1900 list farming as the most prominent career, with the majority of farmers owning their own lands, while others worked as tenant farmers for wealthier landowners. Later, farmers who wished to purchase farmlands worked at the Bethlehem Steel Corporation to earn the money for the land.

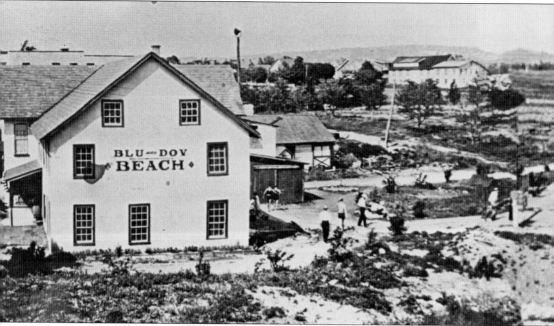

Named after a Czechoslovakian town, the Blu Dov swimming pool sat where today's Village Center can be found, its skeleton buried beneath the foundations and parking lot. Charles Pechacek, a native of Czechoslovakia, owned the Barron House, formerly the Eagle Hotel, when he decided to add a public swimming pool to the town. Modern filter requirements and the overall cost to

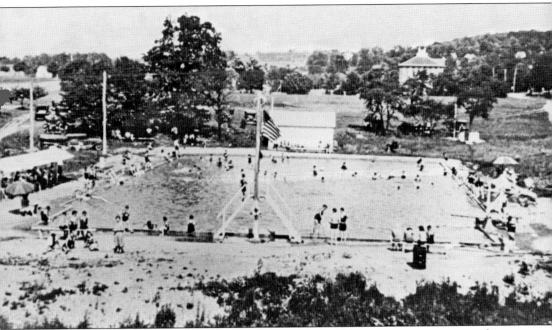

maintain the pool led to its eventual close just after World War II, leaving the community without a public pool. The void was filled in 1961, when the Southern Lehigh Community Pool was dug at the Living Memorial grounds.

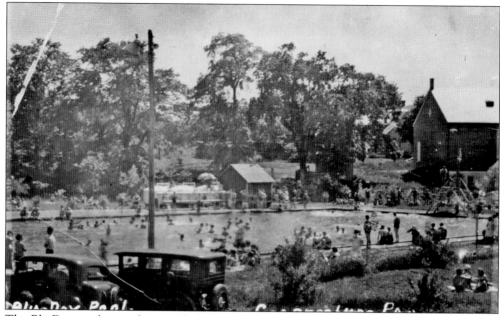

The Blu Dov pool was a luxury when it opened in 1931. A delight to those who lived there, the pool was filled with fresh water from the nearby stream and springs, and its crystal waters attracted regular patrons from as far as Philadelphia. The pumps can be seen towards the left of the pool. At one point, the Calvary Bible Fellowship Church even used the pool for their baptisms. (Donald Bassler.)

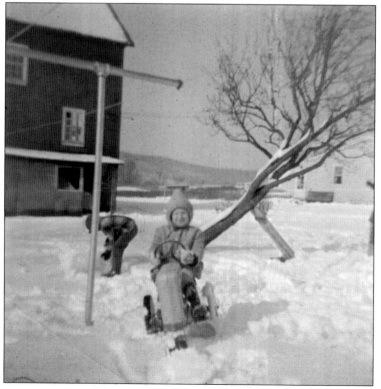

Jimmy (left) and Brenda (center) Donat enjoy a snowy day on their farm along Limeport Pike near the area known as Standard. Brenda takes her pedal tractor for a spin while her brother begins a snowman. The children's father, John Donat, soon replaced the barn seen in this picture with a smaller shed. (Jeff Donat.)

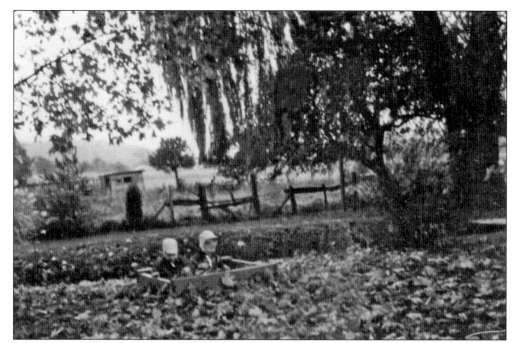

Twins Don and David Donat play in their sandbox along Limeport Pike on a fall day. The Donat farm did not have a well or city water, and water was delivered in trucks. The delivered water was obtained by the township from the Friedensville mine and trucked to homes. This was the solution when the mine's pumps lowered the water table. Behind the boys, the Koczirka farm can be seen. (Jeff Donat.)

The Donat barn has been replaced with this wooden shed. On its left side is a rabbit hutch, and the hole on the right gives Snoopy, the family dog in this photograph, access to the shed. John Donat (second from the left) spends time playing with his sons (from left to right) David, Don, and Jeff. (Jeff Donat.)

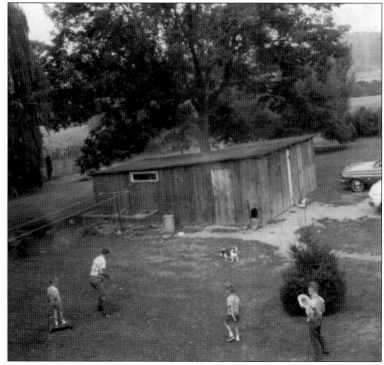

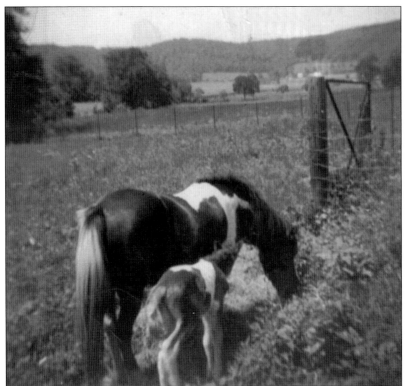

Robert Moyer owned both this pinto mare and her newborn foal, but they grazed on the nearby Donat farm in 1958. When breeding horses or ponies, mares that are near foaling are usually separated from the herd to allow for privacy and to protect the newborn foals. When Moyer's mares were ready to foal, he brought them to Donat's farm until the foals were old enough to be introduced to the rest of the herd at the farm along Vera Cruz Road. (Jeff Donat.)

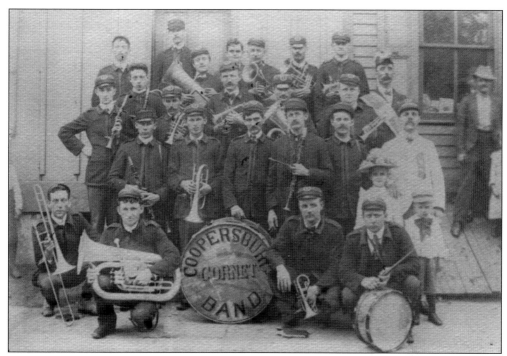

Formed on November 11, 1894, and directed by John Meyers, the Coopersburg Cornet Band raffled hand-made quilts to purchase their original uniforms. John Meyers's son, Albertus Meyers, went on to direct the Allentown Band and became quite well known. The band performed as far away as Durham, but township concerts were band favorites. This photograph is one of the earliest photographs of the band.

A pony gazes towards Vera Cruz Road from her pasture on the land that is now occupied by the Jewish Day School. The farm buildings along Vera Cruz Road stand at the intersection of Chestnut Hill Road. The pony farm was owned by Robert Moyer, who later purchased the Lanark school building that stands along Route 309. (Jeff Donat.)

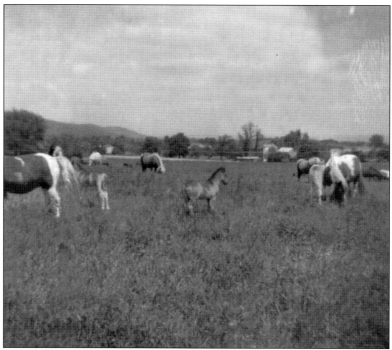

Here the Coopersburg Cornet Band performs on stage in the town hall. For out-of-town performances, a wagon pulled by horses transported the band. Many Coopersburg concerts were held on Sunday evenings on the Kern Carriage building's second story balcony. Other concert locations included the Baldwin House and Midway Park. (Donald Bassler.)

Bands were pleasant entertainment in the community during its early days. The Coopersburg Minstrel Band takes its bow after performing on stage for the Lions Club. The Independent Order of Odd Fellows (I.O.O.F.) Lodge No. 390 in Coopersburg also conducted minstrel performances in the town hall. (Donald Bassler.)

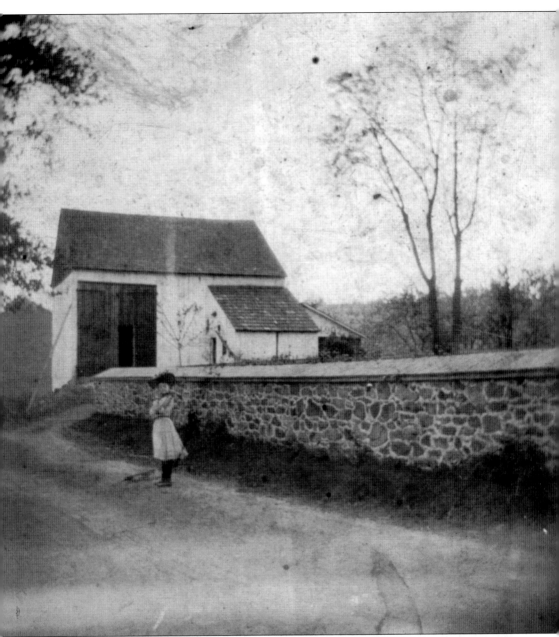

Standing along the wall at the Blue Church, Elsie Simon enjoys a beautiful day in the countryside. The wall lines Blue Church Road just past the church and across from the sexton's house. The sexton's duties included digging graves for the cemetery and tending the church grounds. This stone wall was removed in 1930 when the road was widened, and a stucco wall replaced it. Later the dirt road was paved, and more than 60 years later, the barn was removed as well. Blue Church Road was an important route through the township, beginning just outside the township line in Limeport and then splitting to meet both Lanark Road and Old Bethlehem Pike outside of the township. Early road records indicate it was one of the few original roads through the township. (Blue Church.)

The landscape along Blue Church Road looks much different than it did in 1938. The dirt, one-lane road passes in front of the Madle farmhouse and barn here. Both the house and barn remain, but they are surrounded by many more homes than in this photograph. (Blue Church.)

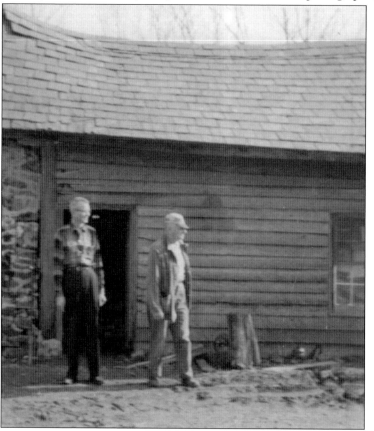

Walter Toepfer (left) visits with Marvin Urmy on his farm. Seen behind them is the original log cabin of the farm. The Urmy farm is the township's only remaining dairy. Originally, John Yeakel's dairy and the Home Farm Dairy were on Station Avenue, while Spring View Dairy was on Jacoby Road, and the early Upper Saucon Dairy was known to be operated by P. Kelly in the township. (Urmy family.)

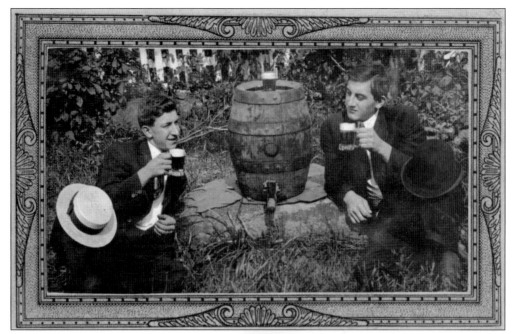

Relaxing at a get-together in the Blue Church area, George Simons (left) and Charlee Fried pose for a photograph by a keg of beer. Social activities and picnics often revolved around the community churches, and people traveled long distances to attend both the events and the services. Some Blue Church attendees in the early 1900s stayed overnight in barns for the morning service. (Blue Church.)

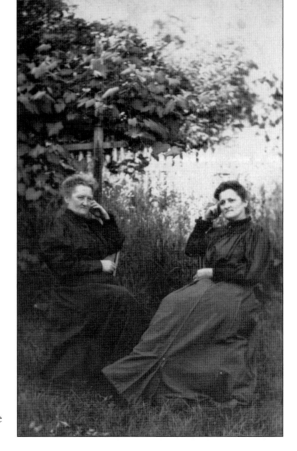

In the same scenic location, these women take a break to relax in the garden. Both are part of the Geisinger family, one that operated a mill in Center Valley. Their faces and intent eyes indicate other activities taking place beyond the photograph. (Blue Church.)

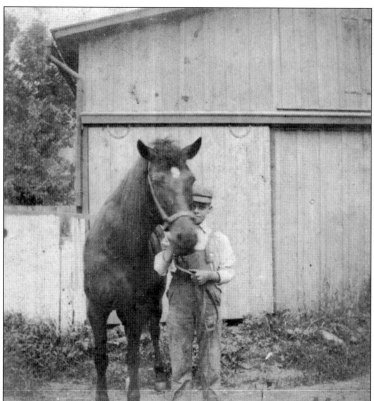

Herbert Gehman, son of A. O. Gehman, poses with a fine steed. After the Cooper Cattle Sales ended, the Coopersburg Lions Club filled the void with annual horse shows on the same lawn where the cow auctions had been held. These equine sales ran from 1944 to 1957.

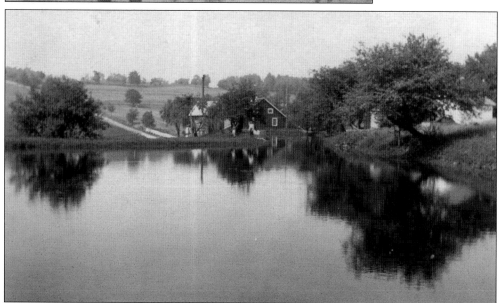

Without a public sewer system, the growing town began to pollute the many springs that fed the Coopersburg pond. Here was the home of Jonathan Koch's ice business. However, without crystal-clear ice, the business folded in the late 1920s. The ice building was destroyed in 1937, and its granite stones were used as a cornerstone for the addition to the Coopersburg Junior High School.

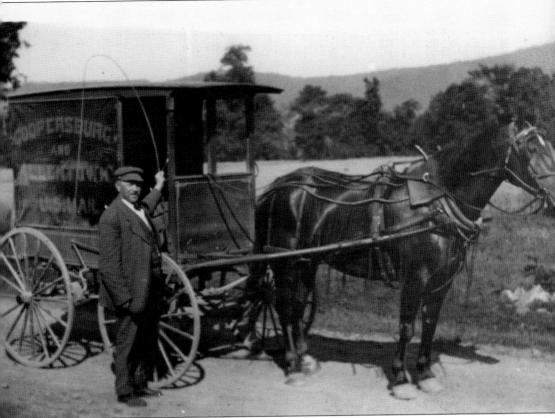

Henry Hartman takes a break from his mail route through the township during the late 1920s. Several postal configurations were used in the township before the establishment of the rural free mail delivery system ended these smaller routes. The original Saucon Post Office was established on August 25, 1841, on the Mory homestead along Lanark Road across from Preston Lichtenwalner's farm. It then moved to the Whitman home at the corner of Lanark Road and Vera Cruz Road on July 25, 1862, when it was renamed the Lanark Post Office. The route soon came to be known as the Star Route, and postmen like Hartman received mail by train and delivered it throughout the township.

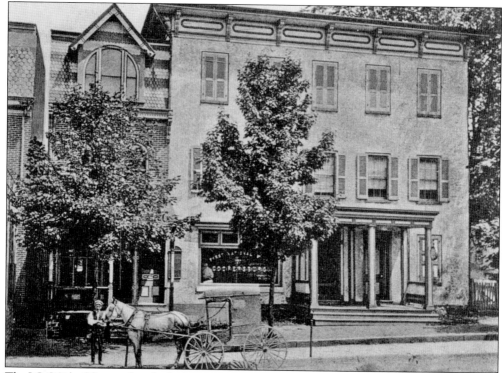

The I.O.O.F. building sits beside the Van Ness House. In 1899, the post office once again moved, this time to the first floor of the I.O.O.F. building. At this time, Jeremiah Fetzer and his wife, Anna, were postmasters. As seen in this photograph, the building also served as a bank. The small building on the left was added in 1896, and a Mr. Schmidt operated a barbershop on the second floor in 1898.

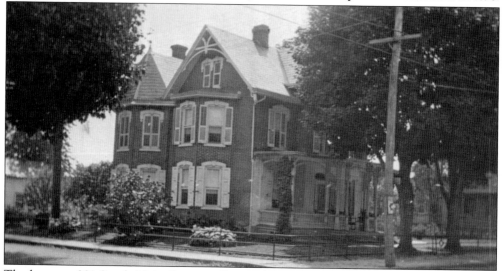

The home at 201 South Main Street in Coopersburg has changed very little over the years. Representative of the style of home built in Coopersburg during its early years, the home has working shutters, several peaks on the roof, and a sitting porch. The rail fence around the yard was also common for a Coopersburg home, as most homes had fences of some type along their front yards.

Owned by Mildred and Harvey Bassler, this home originally sat at 101 North Main Street in Coopersburg, part of the original Henry Ritter farm. As streets were added to the town, the home found itself in the path of the planned Oxford Street. Too sturdy to demolish, it was moved to its new address at 526 Oxford Street. The couple lived in the home for 45 years, until 1977. (Donald Bassler.)

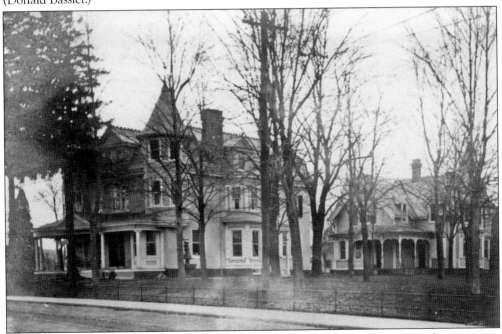

Before Tilghman Cooper renovated the estate and renamed it Linden Grove, two homes sat on the Cooper family property at the edge of town. The home in the foreground became the home at Linden Grove. However, while renovating, Cooper found that the late-1880s home in the rear needed to be moved in order to make room for a new office building. Structurally sound, it was senseless to raze the building.

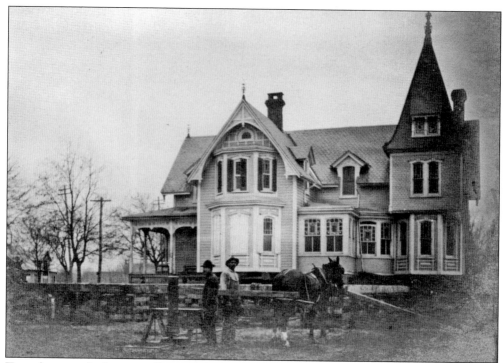

To make room for his new office, Tilghman Cooper had the house in the rear of his property moved in 1906. It only moved a short way, but it was a slow move to its new location at 406 South Main Street, where Ralph Cooper Sr. and his family took residence in it. It took three months for horses to drag the home along the wooden pallets that lined its new path. The house is seen moving along the wooden foundation that served as a track leading to its destination. Tilghman Cooper's cattle sales office was erected on the original foundations of the home shortly afterward, and he renamed the Cooper estate Linden Grove.

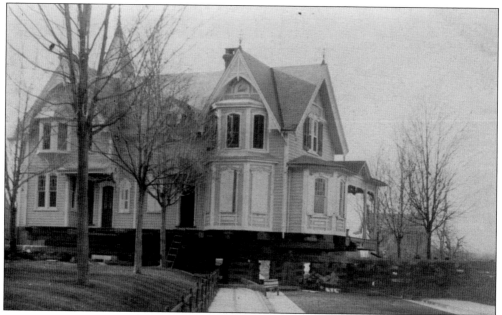

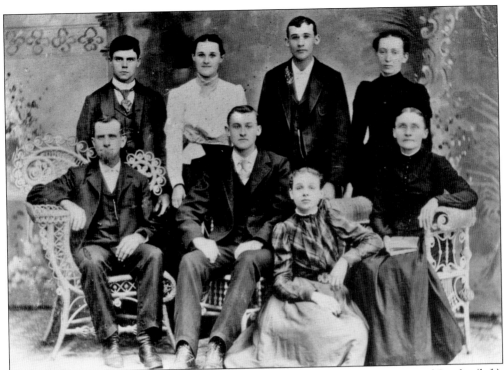

The Bassler family poses for a portrait. The three people seated on chairs are David Bassler (left), his son Allen Bassler (center), and his wife, Sarah Bassler. The rest of the members are most likely David and Sarah's children and their spouses. Allen's son is Harvey Bassler, who took many of the photographs in this book. (Donald Bassler.)

A fine automobile is parked in front of Donald Bassler's home on State Street. Bassler later added a Franklin Ford to his garage after purchasing it from the Kenneth Kern estate. Bassler worked for Kern and also refurbished antique cars, providing them for various events around the valley as well as the America on Wheels museum in Allentown. Donald Bassler is the son of Harvey Bassler.

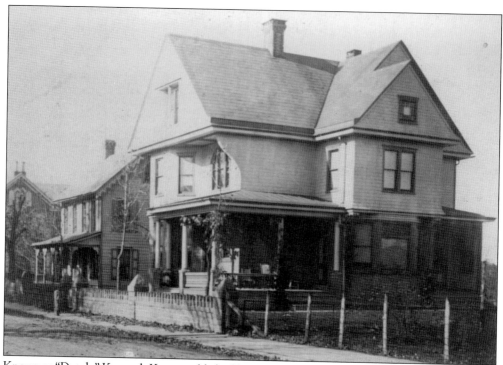

Known as "Dutch," Kenneth Kern established himself as one of the foremost Franklin automobile mechanics. When parts for the Franklins were not available, Kern made molds to create his own pieces. Born into transportation, Kern, as well as his brother Connie, maintained careers as automobile mechanics after their family carriage-building business was consumed by the horseless carriage.

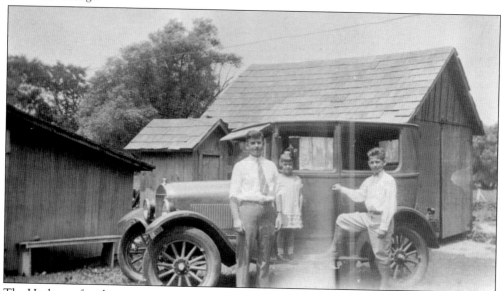

The Hackman family poses in front of their family car with G. Hackman on the left, Eileen in the center, and Herbert at right. Herbert Hackman later served as the first president of the Coopersburg Home Fair. As more families purchased cars, the ever-popular trolley route was moved west of Coopersburg on September 2, 1925, freeing up Main Street for automobiles.

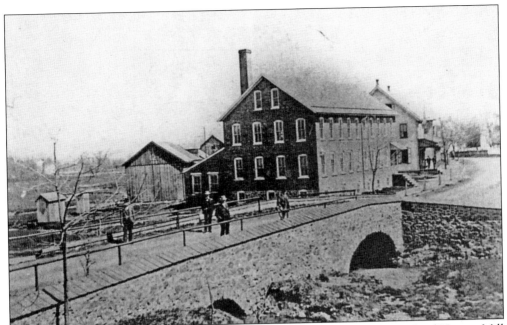

Men pause on the stone bridge along Main Street in Coopersburg with the Gabriel Hosiery Mill behind them. The bridge was built for access to town before 1861. Note the outhouses seen behind the factory. Work on public sewer lines in both Coopersburg and Upper Saucon began in 1972, with a joint facility located near Route 378.

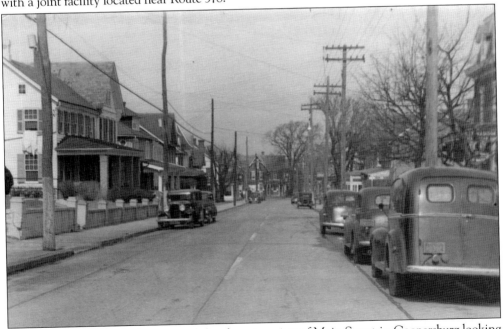

Photographers regularly documented the changing view of Main Street in Coopersburg looking north towards the curve at State Street. What started as a dirt road was then paved with stones. In 1901, trolley tracks and overhead wires were added. In this later photograph taken near Station Avenue, the trolley tracks have already been pushed west by cars, and the hitching posts seen in older photographs are gone.

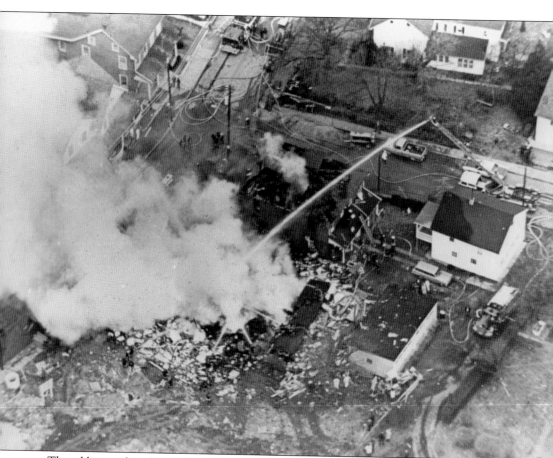

The addition of a public sewer system in Coopersburg had its drawbacks. Near noon on February 21, 1973, a gas pipe was ruptured during sewer construction, causing this explosion. The blast destroyed an apartment building and triggered a fire that gutted two homes. Four people were killed in the blast and one from the fire, while many more were seriously injured. Debris was scattered throughout the town, causing further injuries and damage from the powerful blast. Debris spread as far as the Urmy farm, injuring one of the cows there. The following day, residents were alerted to more gas fumes, but while it unnerved the town, it did not cause further damage. (Donald Bassler.)

Three

WORSHIP

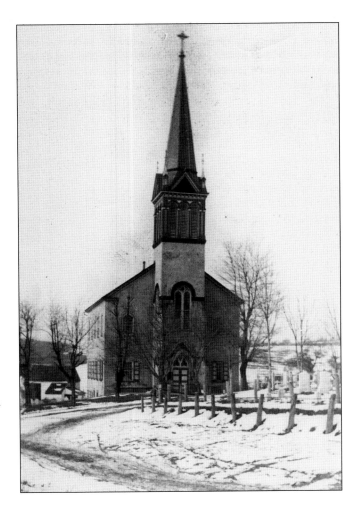

St. Paul's Lutheran "Blue" Church, at Applebutter Hill Road and Blue Church Road, is the third and largest church to stand on the property. This 1895 photograph shows its original spire and the tinted plaster that gave it the nickname Blue Church. Most people in the area know the building more by the name Blue Church than by St. Paul's.

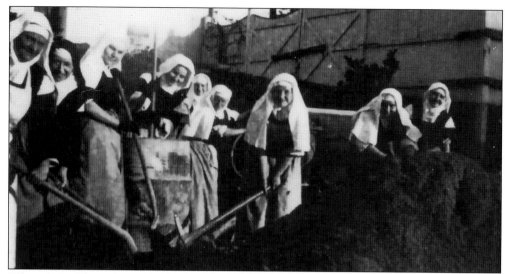

When Sister Therese and Sister Clement Mary first came to Lanark on May 22, 1931, they took mass at nearby St. Joseph's Church before purchasing Lanark Manor for their monastery. On December 8, 1934, the Carmelite Sisters began to dig part of the chapel foundation by hand. Masons finished the work, dedicating the chapel on July 17, 1949. Over 2,000 people attended the first official mass at the monastery. (Carmelite Monastery.)

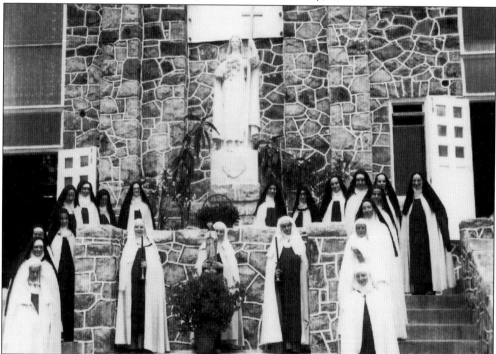

The sisters of the Carmelite Monastery along Lanark Road stand in front of the completed chapel. Sister Therese and Sister Clement Mary purchased land from the Weibel estate, land that included a 17-room house and a stone garage that was converted into the novitiate. Mr. Weibel was hesitant to sell his land for such religious purposes, but he was won over by Sister Therese's charm and persistence. (Carmelite Monastery.)

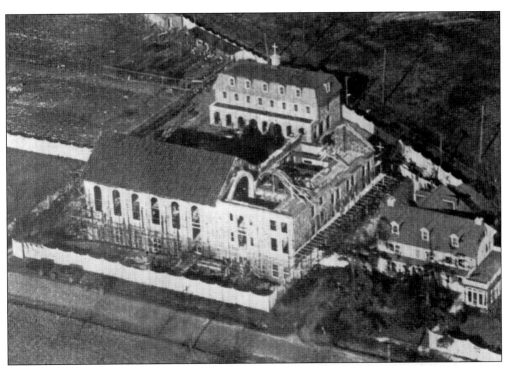

The Carmelite Monastery is shown here under construction in early 1930s. The novitiate (top) was originally a barn on the Weibel estate, and the farmhouse that was on the land when it was purchased is on the right. The trolley lines branched away from their parallel run along Lanark Road and crossed through the monastery property, running along the wall. (Carmelite Monastery.)

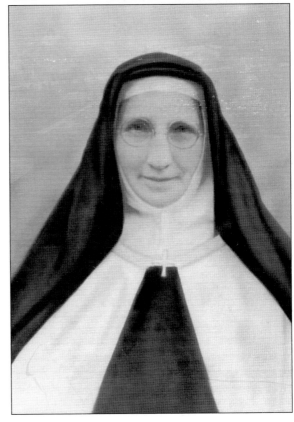

Sister Mary Therese was born in Muenster, Germany, as Maria Anna Lindenberg. She came to the United States in 1901, and after returning home to Germany, she returned to the United States in 1930 to establish a Carmelite monastery. Mother Therese died at 10:15 a.m. on April 11, 1939, at the age of 62. (Carmelite Monastery.)

This view of Evelyn Borger's house shows her family's home in the original parsonage of Coopersburg Moravian Church. Borger served as the historian in the Coopersburg Historical Society in 1976, when she wrote the town's history in the book *Coopersburg: Town of Possibilities*.

Services for a Moravian congregation in Coopersburg began in the I.O.O.F. building on Main Street. Once a month, members gathered for two sermons—one spoken in German and another spoken in English by Pastor L. P. Clewell of the Emmaus Moravian Church. The charter for the Coopersburg church was earned in 1883, and this church building on Main Street, as well as its neighboring parsonage, was dedicated in May 1884.

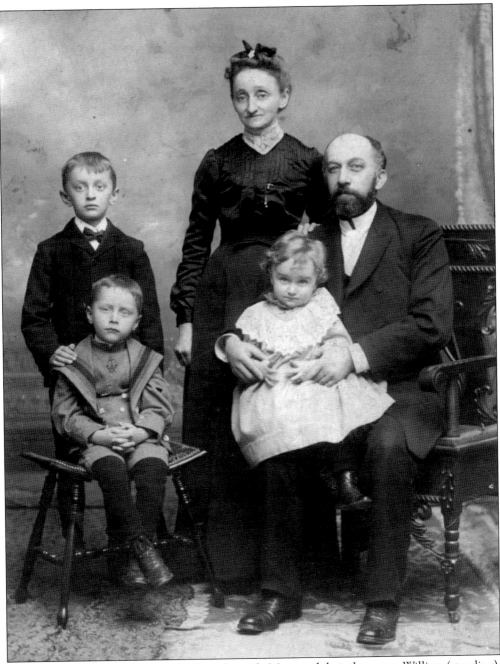

The W. W. Kistler family includes William, his wife, Mary, and their three sons William (standing), Myron, and Daniel (seated on Mr. Kistler's lap). Daniel grew to follow his father into the clergy, and Pastor William W. Kistler and his son Pastor Daniel D. Kistler served the Coopersburg parish from 1894 until 1950. The parish serviced Blue Church, St. John's United Church of Christ in Coopersburg, and New Jerusalem Lutheran Church in Leithsville. During his career, W. W. Kistler baptized 2,508 people and confirmed 1,500 parishioners. He officiated 1,714 funerals, and he married 776 couples. For his entire career, W. W. Kistler only served one parish, that of Coopersburg. W. W. Kistler died on Friday, January 5, 1940, at the age of 78. (Blue Church.)

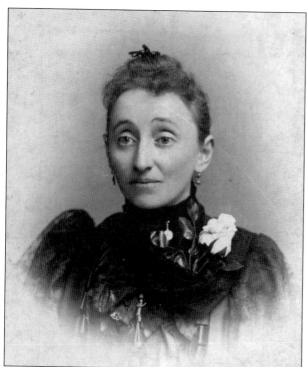

Mary Evaline (Mantz) Kistler had her photograph taken on May 19, 1897. She married the soon-to-be pastor W. W. Kistler on July 1, 1894, just as he completed his appointment as student supply pastor of the Coopersburg parish and became the permanent pastor. Mary's son Daniel became the pastor of the Coopersburg parish, and two of her grandsons, Luther and David, also became pastors. (Blue Church.)

Pastor W. W. Kistler was known for his buggy visits with his horse, Maggie. Since he was awarded no salary for his pastoral work, he collected goods from his parishioners. He had a compartment under the seat of the buggy for food donated by his congregation, and if he was invited for dinner he would say, "Maggie is hungry, too." (Blue Church.)

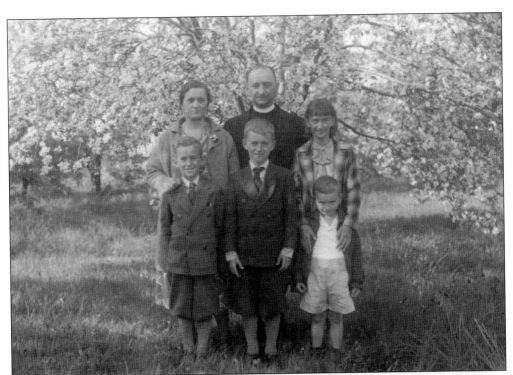

Pastor Daniel Kistler served the Coopersburg parish from 1933 until 1950. He was invited on July 17, 1933, before his father's retirement and remained in service until the parish dissolved. His wife and children stand with him here beneath the springtime blossoms. From left to right are (first row) Luther, Daniel, and David; (second row) Jessie Dean Kistler, Pastor Kistler, and Constance. (Blue Church.)

Pastor W. W. Kistler and his wife, Mary, dress in their finest to honor Blue Church's 200th anniversary in 1939. Kistler served first as a student supply pastor in 1893 and then as the official pastor from 1894 until his retirement on October 1, 1933. Kistler died on Friday, January 5, 1940, only a few months after this photograph was taken. (Blue Church.)

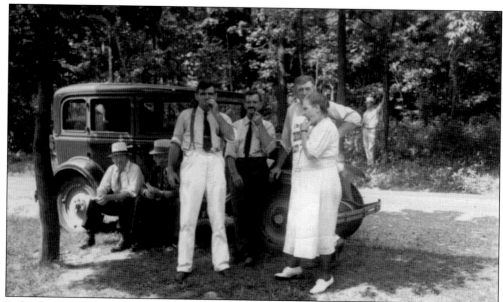

Robert Sterner (left) and Oliver Sterner (center) stand beside Peter Ohl and his wife, Stella, during a picnic at Blue Church grove. Both of the Sterner men worked for the Lehigh Transit Company on the trolley lines, while the Ohls farmed the land on their Upper Saucon Township farm. (Blue Church.)

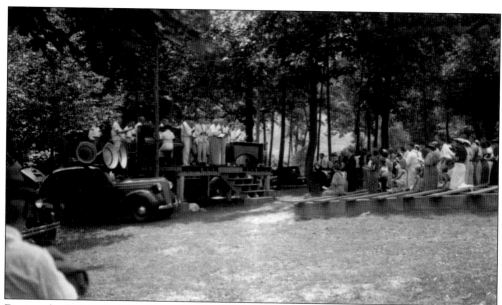

During the 1930s, the Blue Church Sunday school held an annual summer picnic at the church grove to raise funds for the classes. Members of the community performed songs, skits, or recitations for the audience. Notice the speakers atop the car roof and the full band, including a xylophone on stage for the sing-along. (Blue Church.)

64

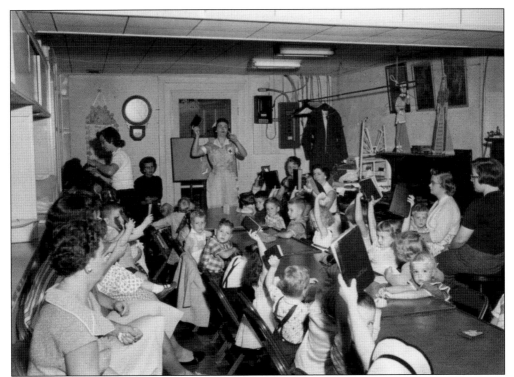

Children who attended the Blue Church Sunday school in the 1950s received prizes for attendance. Tickets were earned and redeemed for Bibles or stickers were added to a scenic picture card. Perfect attendance pins were given at the end of the year. These primary department students would remain in the classroom in the downstairs kitchen until they were 12. Then they would move upstairs to the older class. (Blue Church.)

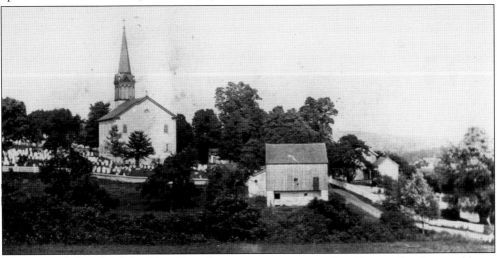

The original church of the Blue Church congregation was made of logs and quite possibly sat where the stone sexton's house on the far right was built in 1858. In 1763, the second church, one made of stone, was built near the present foundation. The new church's cornerstone was set on April 28, 1833. This photograph was taken before 1926, when the church had its tallest steeple and its smallest graveyard. (Blue Church.)

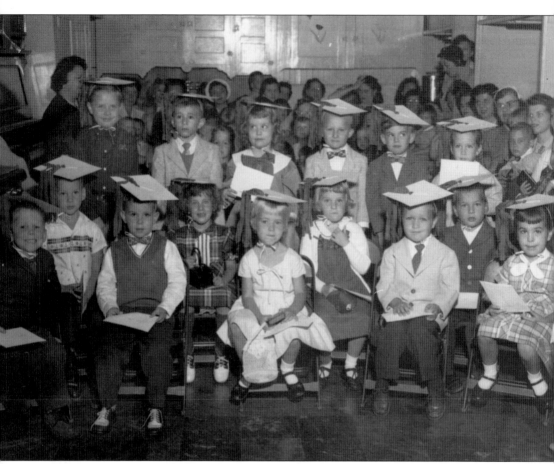

These youngsters pose in the Blue Church Sunday school primary class at the end of the year. Originally, all the classes met together, but in the 1920s, the primary classes were established. Students who were 14 could move to the other Sunday school classes. In 1952, vacation Bible school was established for the summer. The Sunday school held various fund-raisers throughout the year including holiday performances. So popular were the fund-raisers that the Sunday school treasury regularly paid the sexton's salary and purchased heating coal. Several building renovations were paid for by the Sunday school's funds as well. (Blue Church.)

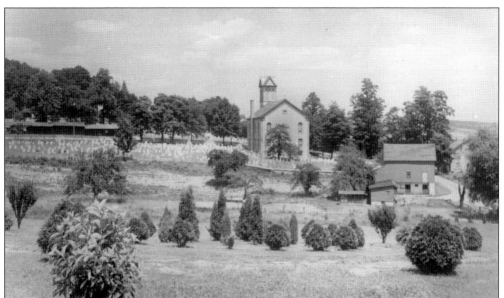

In this 1930 photograph, the new cemetery at Blue Church sits in the foreground, and the bell tower has lost its spire. In the distant left, horse barns line Applebutter Hill Road. These barns were sold to parishioners who wished to park their horses during services. The deeds date back to 1877 for the 9-foot-by-20-foot buildings. By 1940, all of the barns had been torn down. (Blue Church.)

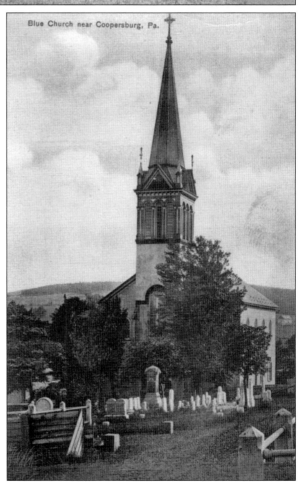

Blue Church near Coopersburg, Pa.

While the 60-foot-by-50-foot Blue Church was built in 1833, the addition of the bell tower and steeple was dedicated on November 29, 1891. The bell that was hung in the tower was cast in Maryland for $628.51. It was short-lived thanks to multiple lightning strikes. Harry Miller removed the steeple on October 13, 1926, the same year that the stained-glass windows were added. (Blue Church.)

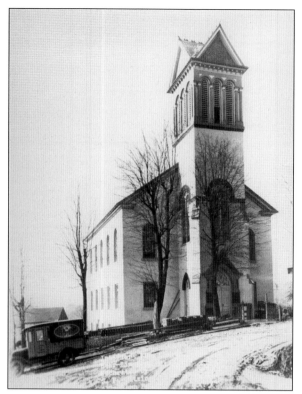

A delivery truck parks along the road during the 1926 renovation of Blue Church. The brilliant white stucco is clearly seen in the sun. Andrew Brunner and his brother plastered the church when it was built, and to create a brilliant white, they added blue pigment. The pigment proved prominent, and the church had a blue gleam to it. Even after the plaster was removed, the name remained. (Blue Church.)

In 1944, the plaster needed to be removed from the church. Attempts were made to paint the church blue, but instead, the entrance doors are the only blue on this 1960 image of the church. The peak of the bell tower was also removed in 1944 due to leaks. Today the bell tower still poses a problem during the rain.

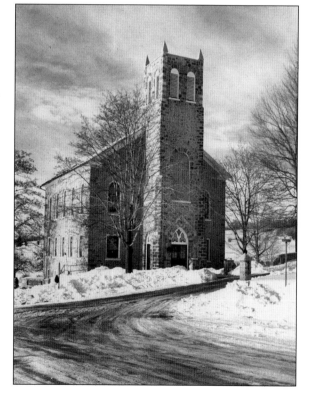

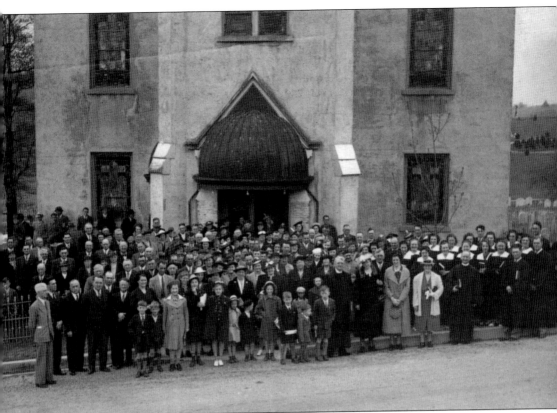

The congregation of Blue Church honors the church's 200th anniversary in 1939 with Rev. Daniel Kistler presiding and Rev. William Kistler emeritus. The copper canopy over the main door was added in 1927, and another was set over the side entrance in 1928. The canopies were removed in 1944. Part of the celebration included a pageant that highlighted the history of the church. Both Rev. Daniel Kistler and Rev. W. W. Kistler researched the church's historical records and worked with John H. Erdman to write the play. Perma Schoch and Lester Bechtel wrote the accompanying music, while Elfrieda Weaver designed the costumes. (Blue Church.)

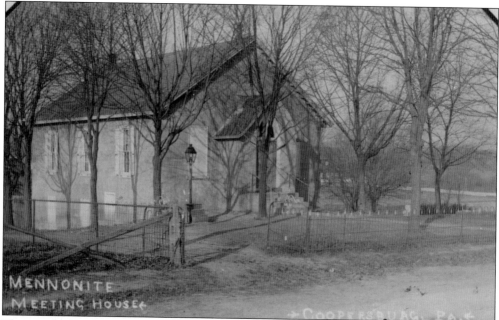

The new Saucon Mennonite Church was built in 1869 on the edge of Coopersburg. Notice the small set of stairs that allow the lamp lighter to reach the light each evening. An addition was made to the building, but eventually that, too, outgrew the large congregation. The newer chapel was built in 1966 beside the original building.

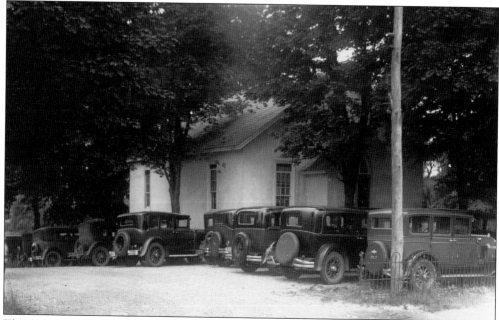

The Calvary Bible Fellowship Church has adopted several names since its incorporation. These name changes reflect its various realignments. The congregation began in 1869 as the Evangelical Mennonites. By 1875, they became the United Mennonites, and eight years later, they adopted the name Mennonite Brethren in Christ. This name lasted until 1959, when they took on their present name. (Calvary Bible Fellowship Church.)

Mildred Musselman poses for the camera as a young girl. Mildred devoted a great deal of time to the Calvary Bible Fellowship Church, documenting its history and teaching a junior class of Sunday school as a teenager. The church's original services were held in Musselman's great-grandfather's barn on Chestnut Hill. Mildred was born in 1914 and continues to be involved in the church. (Calvary Bible Fellowship Church.)

A Sunday school class at Calvary Bible Fellowship Church poses beside the church in 1923. From left to right are (first row) Helen Gross, Dorothy Mann, ? Frey, Mildred Musselman, and Ruth Afflerbach; (second row) Edna Hassler, Marcella Yoder, Grace Bright, and Dora Woodring. Woodring would later marry and become Dora Gehman. She was the daughter of Pastor Richard L. Woodring. (Calvary Bible Fellowship Church.)

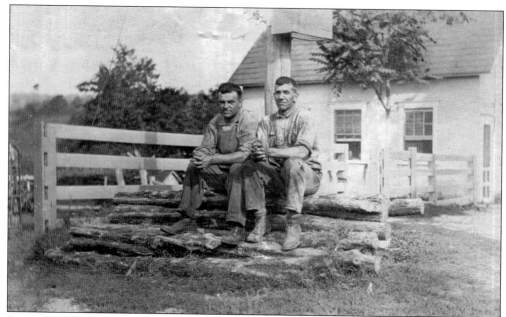

Frank Musselman (left) and Albert Moser take a break from working at the Home Farm in 1923. Musselman served as the manager of the farm. The Home Farm was owned by the Calvary Bible Fellowship Church and operated as a place for the elderly to find peace. Located on today's DeSales University campus, the Home Farm's worship services were often interrupted by noisy, dirty freight trains that passed the property. (Calvary Bible Fellowship Church.)

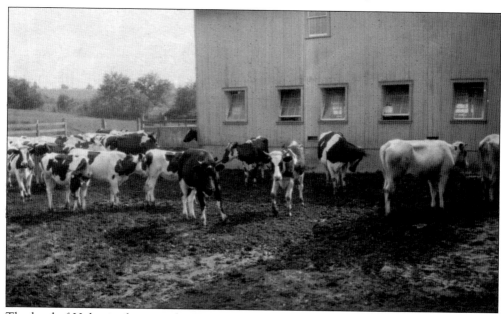

The herd of Holsteins kept on the Home Farm graze before milking. Some church members would venture to the Home Farm in Center Valley during the 1920s for the prayer meetings, but many stayed in Coopersburg and worshipped above Herbert Gehman's hardware store during winter months. Frank Musselman served as a hired hand on the farm before working as manager. (Calvary Bible Fellowship Church.)

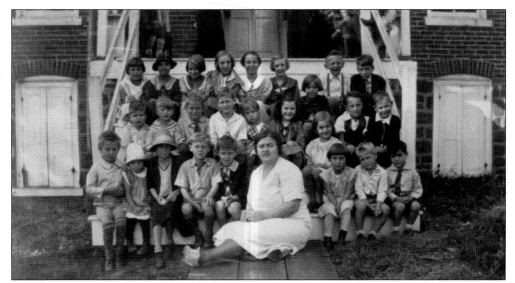

Addie Baus and Walter Brunner gathered the help of others at the Calvary Bible Fellowship Church to conduct afternoon Sunday school classes in the nearby town of Shelly Station. The children of Shelly Station would gather in the cigar store, where the lessons were taught. Addie Baus sits with the children of the Shelly Sunday school. (Calvary Bible Fellowship Church.)

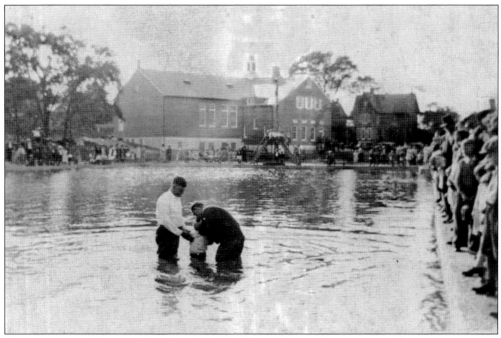

The baptisms at Calvary Bible Fellowship Church have changed locations over the years. Originally, flat stones were laid across the Saucon Creek behind the church for members to step on while being baptized. Lulu Wismer and Herbert Gehman remember frigid baptisms in winter months that required ice to be broken from the water before the ceremony could begin. Later, members like the man seen here were baptized in the Blu Dov swimming pool. (Calvary Bible Fellowship Church, photograph by Mildred Musselman.)

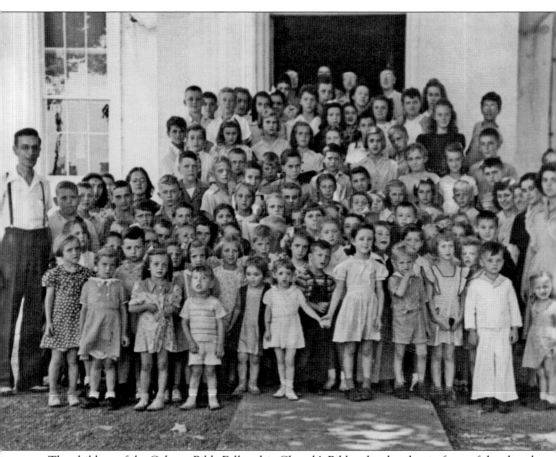

The children of the Calvary Bible Fellowship Church's Bible school gather in front of the church. Rudy Gehman (left) was the pastor at the time. His wife, Dora Gehman (far right), also stands with the children. Gehman served as pastor from 1954 through 1956. The children were the reason that an addition was made to the rear of the church in 1953. This allowed the congregation to add a classroom, a nursery, and indoor plumbing to the church. In 1945, Pastor Walter Frank began the tradition of vacation Bible school, an ongoing tradition at the church today. (Calvary Bible Fellowship Church, photograph by Len Buck.)

Four

SCHOOLS AND SCHOLARS

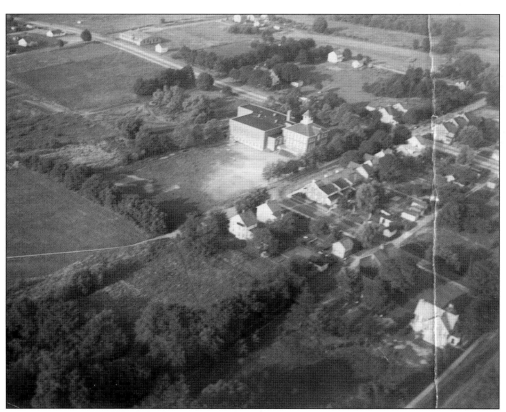

The Coopersburg School can be seen in the center of this photograph at the corner of Third and State Streets. In 1927, Third Street and the Old Philadelphia Pike became part of the state highway Route 309. Several houses were destroyed during the construction of the highway, changing the face of Coopersburg. In 1974, Route 309 was widened to a four lane-highway, destroying more buildings, and it was widened even further in 2009. (Donald Bassler.)

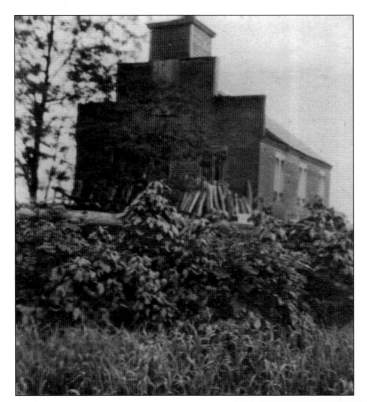

Known as the Octagon School because of its odd shape, the early school located on Locust and Tilghman Streets in Coopersburg was razed in the late 1920s for a private residence. Joseph Jacoby taught here from 1862 to 1882 before being asked to teach at the new elementary school.

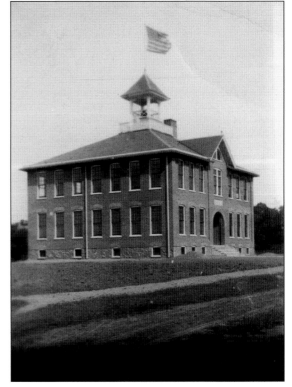

The Coopersburg School was designed by Genaah Jordan and was built in 1909 for $7,771.25. It sits on the same block where the East State School sat before being replaced with this building. Originally an elementary school, the Coopersburg School later housed grades 1 through 10 as a junior high school. Those students outside Coopersburg who wanted to attend grades 9 and 10 walked to the junior high school. Their tuitions were paid by the township. (Donald Bassler.)

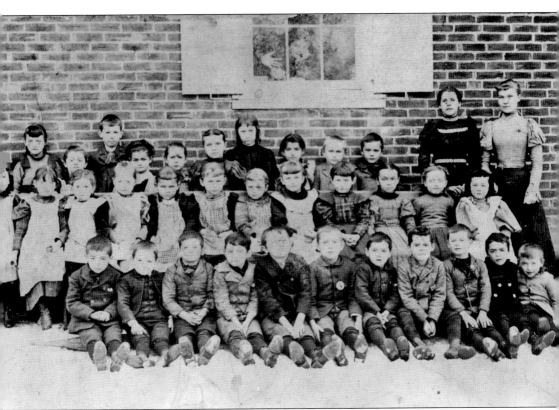

Students pose for a picture at the original graded school in Coopersburg It was located on the southeast corner of Third and State Streets and housed grades one through eight. It was commonplace for students to pose for a yearly photograph of their class. In this photograph, teacher Lottie Virginia Schaffer Cooper (far right) poses with her students in front of the school. The focus on schooling increased as Coopersburg developed. In 1880, the school year was only six and a half months long. By 1913, the school year was extended to nine months with the school days lasting from 8:30 a.m. until 3:30 p.m.

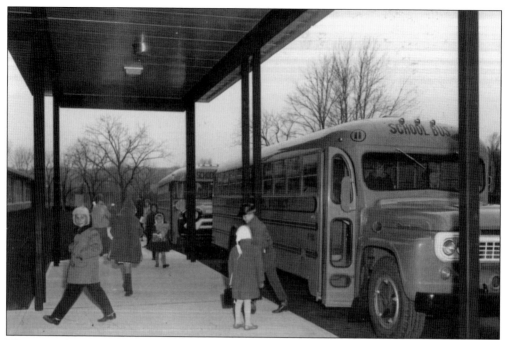

The new Liberty Bell Elementary School opened in 1963 (above). Compared to the schools it replaced, the first day of school looks quite different, with district busses pulling to the front door to deliver the students. Some things are similar, however. The bell of the first graded school called students from 1876 until the new Coopersburg Elementary School was built in 1909. There, it rang until 1938, when electric bells were installed and it was no longer needed. The landmark was then sent to basement storage, where it sat until 1963. Upon completion of the new Liberty Bell Elementary School, a school named in honor of the old trolley route with the same name in the same location, the bell was placed on display in front of the school (below). (Both, Liberty Bell Elementary School.)

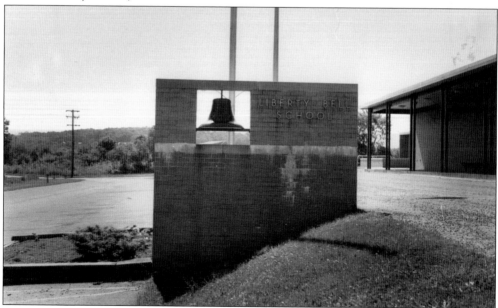

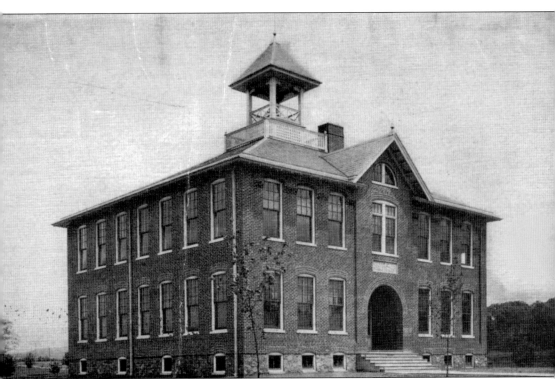

The number of students who traveled to nearby high schools to complete their education was growing, and a local high school was needed. In 1937, an addition was made to the Coopersburg School allowing grades 11 and 12 to attend the school rather than nearby Allentown High School or Liberty High School. Those living near Lanark awaited the trolley at Preston Lichtenwalner's farm, where they paid $6 a month for tokens. Afterwards, the money was reimbursed to the students by the township. The first class in Coopersburg graduated in 1940. By 1957, the new Southern Lehigh High School was established.

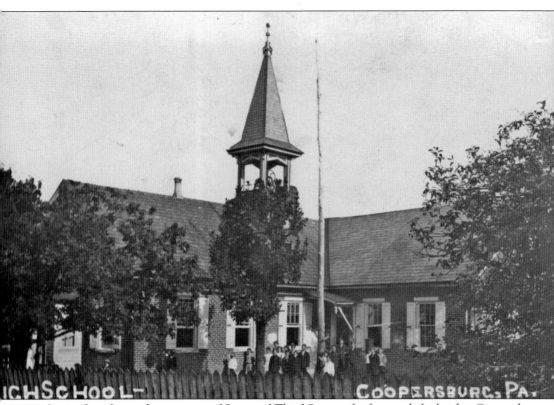

Located on the southeast corner of State and Third Streets, the first graded school in Coopersburg started calling children to its classrooms in 1876. Two additions were made to the building over the years, giving it an L-shape. The grades were divided into separate rooms in comparison to the one-room schoolhouses throughout Upper Saucon Township. This was one of the factors involved in Coopersburg's separation from the township; the people of Coopersburg needed different schools, roads, and utilities than the farms in the township. A separate governing borough could provide for this growing community.

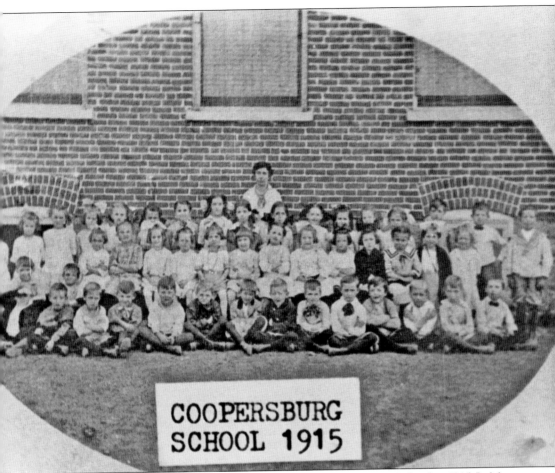

COOPERSBURG
SCHOOL 1915

These proud elementary students sit outside the Coopersburg Elementary School in 1915. In May, they would host a May Day field day celebration with athletic competitions and a maypole. In a survey taken five years earlier, the average pupil attendance rate was 95 percent, the highest percentage achieved among county schools surveyed. At the time, the school had nearly 100 students regularly reporting for class, though many others were registered. The average salary at this time was $84 a month for male teachers and $50 a month for female teachers. For comparison, by 1940, the teachers' salaries had increased to $250 a month. (Donald Bassler.)

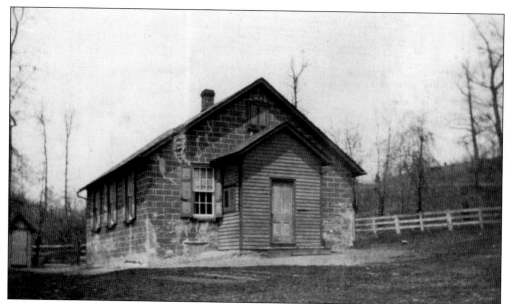

Before 1879, the township schools were mostly run by churches, with the most prominent being the Saucon Mennonite Church, the Friedensville Lutheran Church, and the Blue Church, seen here. Some classes were held in private homes. All of the schools taught their lessons both in German and English because of the high German population in the area. At that time, the teachers not only taught the lessons but cared for the school buildings and tended the fires that kept them warm during the winter months. The Blue Church School building was built in 1867 and started to show signs of aging before it was sold in 1982 as a private residence. (Both, Blue Church.)

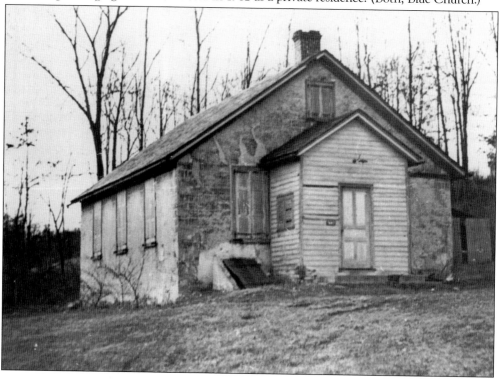

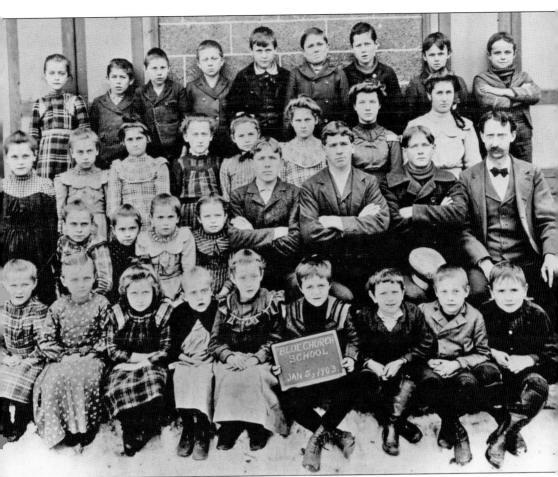

On January 5, 1903, the students of the Blue Church School took time away from their studies to pose for their class photograph. The range of ages in this one-room schoolhouse can easily be seen on the faces of the students. The students who finished the eighth grade took a county examination at the Center Valley School to earn their diplomas. Those who passed the exams would receive diplomas and celebrate graduation in June. The Blue Church School started classes in the church in 1745 before moving to this school building in 1868. It was closed in 1940, sending its students to larger area schools. (Blue Church.)

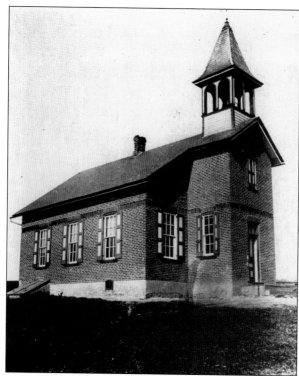

The school law of 1834 required public schools for the township, rather than church schools. The law upset residents who worried that their children would lose their German language and their love of farm life. Residents adamantly opposed the non-mandatory law and did not pass it in the Upper Saucon Township until 1848. The Standard School was built in 1896 to replace the Seider's School and uphold the new law.

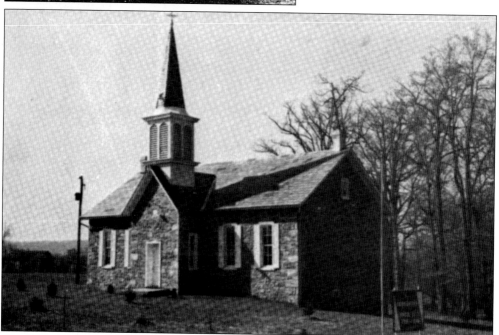

The Dillinger School was one of the new schools built in 1859 under the new school law. It was along Limeport Pike, and like many new schools it fit the classic school style. The students of the Dillinger School were provided with maps, flags, textbooks, and paper as part of their school day without extra expense. The community was expected to pay for all of the Dillinger School supplies.

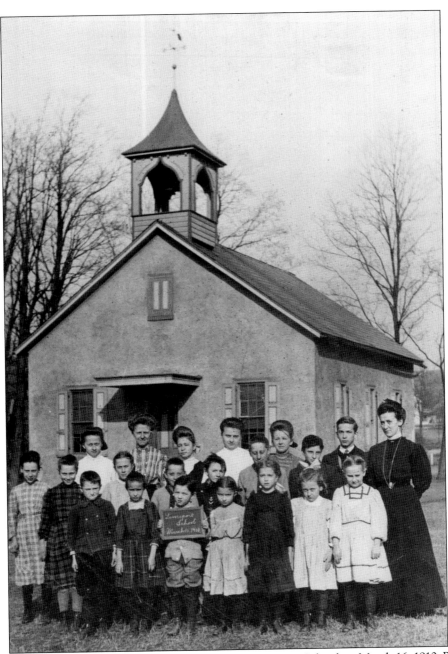

This idyllic school portrait was taken in front of the Limeport School on March 16, 1910. Before the school law of 1834, small schools like this one dotted the area, and there were three schools located in the Standard and Limeport area. Some earlier schools were conducted in homes, many in churches, and others in smaller school buildings before these typical school buildings replaced them. The teachers were often graduates of the schools that they taught, and a few began teaching as young as 16. In 1950, when Upper Saucon Township, Coopersburg Borough, and Lower Milford Township decided that pooled resources would create a better educational system, the Southern Lehigh School District was chartered. The new Southern Lehigh Junior-Senior High School was completed in 1955. (Blue Church.)

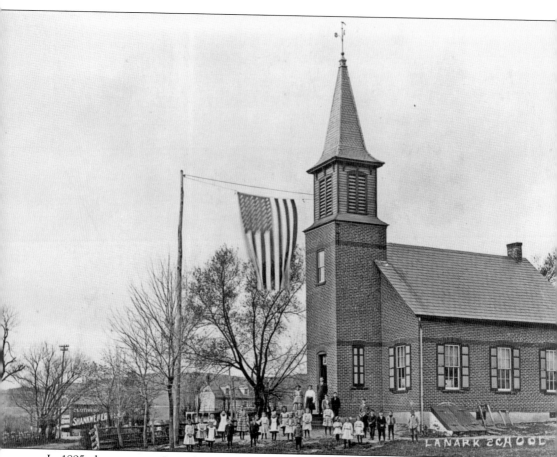

In 1895, the one-room Lanark School along Saucon Valley Road replaced the earlier association school known as Heller's School. Heller's School was built in 1809 near the tavern of the same name, as seen in the background along Lanark Road. In the 1940s, the new Lanark School, facing Route 309, replaced the school shown here. Both Lanark schools remain today, this one as a private residence and its replacement as lawyers' offices. At the end of the year, teachers in the area gave their students souvenir photographs of themselves with a class list on the back. Some of the student names became teachers' names as graduating students returned to teach their former classmates. Mrs. Laubach, George Trexler, and Adelaid Mullen were three of these returning students at the Lanark School.

Five

INDUSTRY AND ENTERPRISE

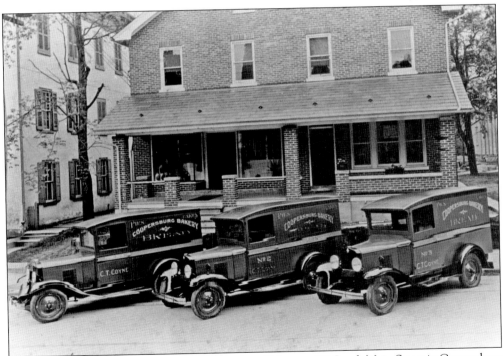

Charles and Emily Coyne operated the Coopersburg Bakery at 111 South Main Street in Coopersburg from 1929 until their retirement in 1955. While the bakery operated in the front of the building, the family lived in the rear half. The three Chevrolet trucks parked in the front delivered the fresh breads throughout town.

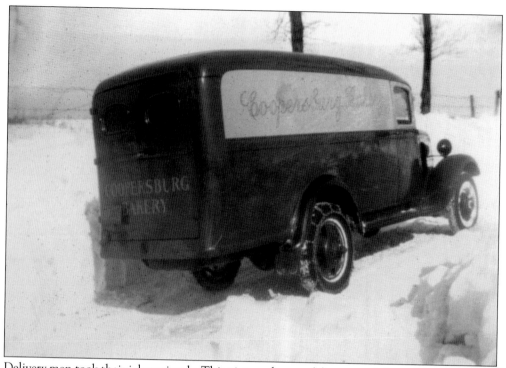

Delivery men took their jobs seriously. This picture shows a delivery truck from the Coopersburg Bakery, operated by the Coyne family, trudging through the snow with snow chains. The trucks would drive to the rear of the building, where a large loading area allowed for their easy access. (Donald Bassler.)

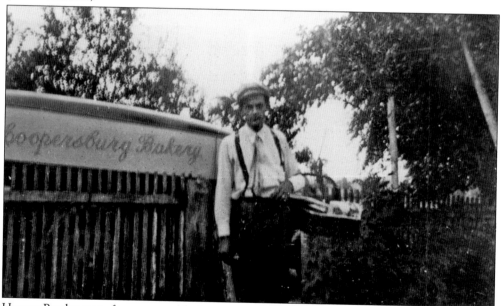

Harvey Bassler stops for a moment before resuming his route for the Coopersburg Bakery. The left rear side of the bakery was home to the Coyne family, while the right rear side was home to Elbert Roth, the baker. Roth shared his half of the building with the storeroom and the window displays facing Main Street. (Donald Bassler.)

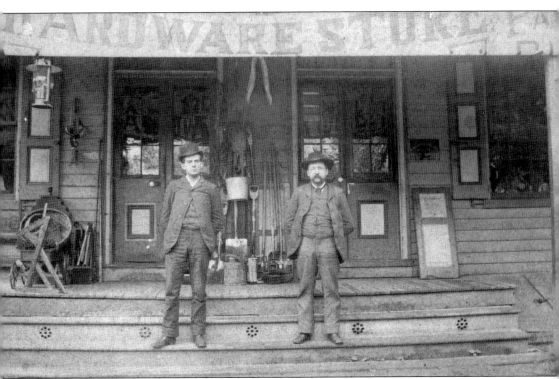

Alvin "A. O." Gehman (left) poses outside his store in 1889 with postmaster Thomas Stevens. Gehman's store on Main Street beside the Barron House served as one of the first post offices in Coopersburg. The trains brought seven mail stops a day to the town. From there, postmen delivered the mail along their routes through town. Many residents set their clocks by the delivery of their mail, hearing the horse's hooves marking time as they made their way down the streets. There were many buildings that served as post offices until a permanent postal building was constructed in town.

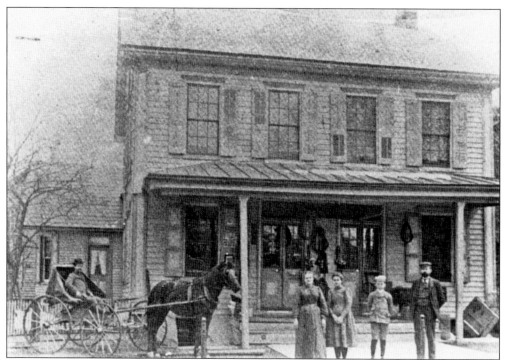

This early photograph of A. O. Gehman's store shows the activity surrounding the store. One employee, J. Harvey Baus, who later took over the Ritter Funeral Home, earned $8 a week to work 12-hour shifts, sometimes longer. While this salary seems low, it was enough to enable him to purchase a home and support his family of four children.

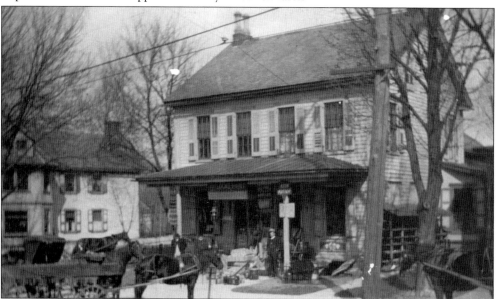

Several buildings in Coopersburg were moved over the course of their existence. Originally, a carpenter's shop sat here. Once it was moved, this building housing Gehman's hardware was built on the empty foundation in 1869. A. O. Gehman did not take ownership of the business and the building until 1889. The Barron House is on the left.

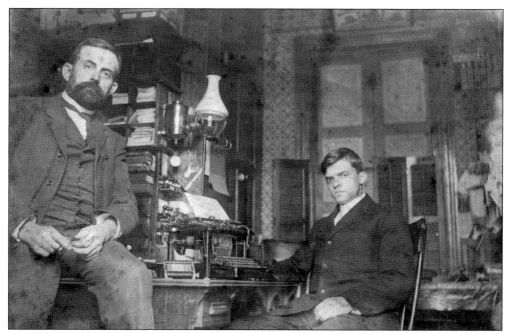

A. O. Gehman's office at his hardware store shows the workings of a turn-of-the-century business. Gehman sits on the desk at the left. A typewriter, rubber stamps, and pigeon-hole cubbies were the state-of-the-art office supplies when Gehman posed for this picture. After Gehman retired, his son Herbert continued the family business.

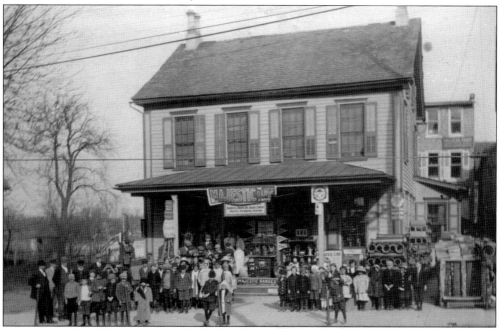

The Majestic Range Company attracted a large crowd at Gehman's hardware during its annual display. Each year, modern kitchen ranges were promoted through special events such as essay contests for children. The company would send its newest models, like the one seen on the porch, for the special event.

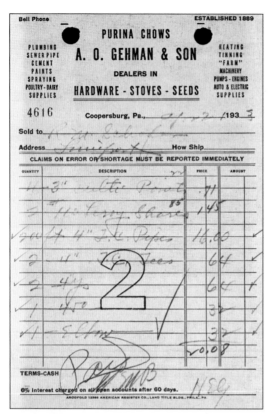

Many residents think fondly of the stores that were in the township before chain stores dominated the retail venue. The stores offered a great variety of items, and children remember browsing their aisles. This Gehman sales slip shows the variety of items sold at the store. R. M. Schafer of Limeport seems to have been working on his plumbing when he visited the store in 1933. (Jeff Donat.)

A. O. Gehman and Son hardware store sat next to the Barron House. The Barron House, originally known as the Eagle Hotel, replaced Der Siebenstern in the 1820s. Der Siebenstern was located approximately between the Barron House and today's town hall. In 1940, the Barron House became the social hall for the Coopersburg Fire Company.

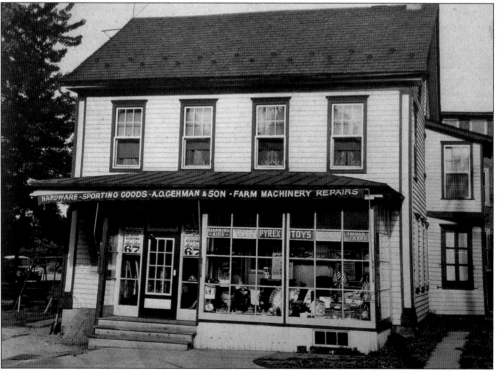

Thomas Kocher had his own stonecutting business next to the Blue Church cemetery. Based on his occupation listed in the census, he worked as a stonecutter between 1901 and 1919. Children at the nearby Blue Church School would watch Kocher cut the stones by hand after tracing his designs onto the stones. (Blue Church.)

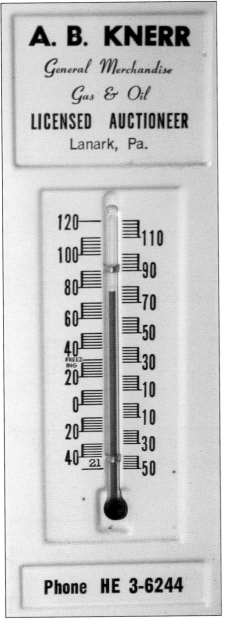

A. B. KNERR

General Merchandise

Gas & Oil

LICENSED AUCTIONEER

Lanark, Pa.

Phone HE 3-6244

This thermometer is an advertisement for Alton Knerr's store in Lanark. The store was housed in the building originally known as Heller's Tavern or Lanark Hotel at the intersection of Lanark Road and Saucon Valley Road. Alton Knerr operated a general store and an auction with a wide range of goods. (Robert Yeager collection, photograph by Kelly Ann Butterbaugh.)

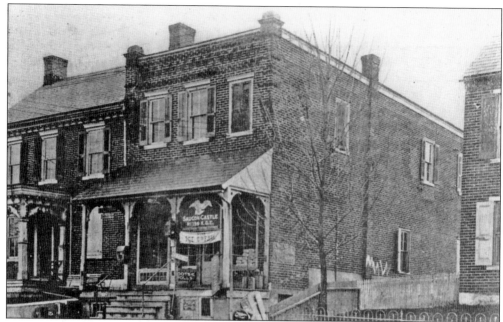

Before the establishment of a rural postal route, post offices in the township were often housed in stores or private homes. The Center Valley Post Office was found in the back of this store along Route 309 until a new post office was built in the 1920s. The position of postmaster was a political appointment, though the storekeeper often was the postmaster.

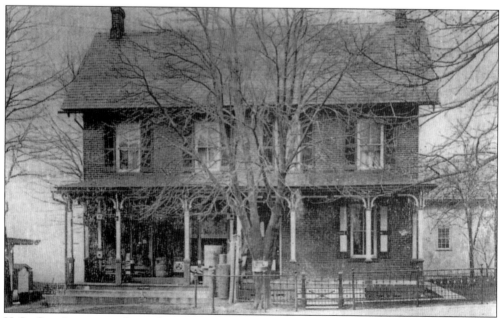

H. L. Gross's store was located on East Station Avenue in Coopersburg, where it relied on the trains to maintain its business. General stores were prevalent in the area thanks in part to the freight trains that stopped in the area. The last operating general store in Center Valley was the Hockman store.

This was the residence of Dr. J. Harvey Lowright in Center Valley. Notably, the photo postcard taken around 1915 spells the town's name "Centre Valley," as do many photographs at the time. In 1900, Lowright quarantined several houses in Center Valley to prevent an outbreak of scarlet fever, then called scarlatina.

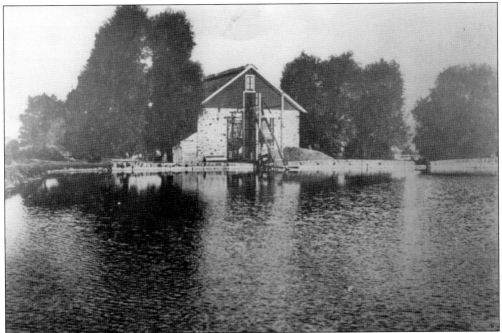

Owned by Jonathan Koch, Coopersburg Lake was a man-made pond. When it froze to a depth between 16 and 24 inches, Alfred Keiss cut blocks of ice and pulled them with horses up the ramp for storage in this stone ice house to the west of the lake. The ice was packed between sawdust and sold in the summer months to those with ice chests.

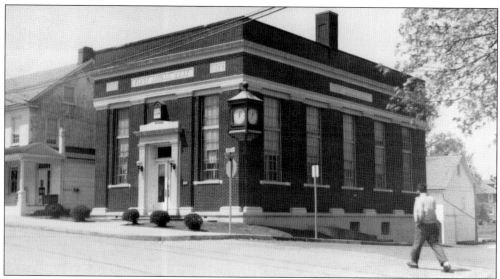

The First National Bank in Coopersburg was built in 1923. Before that, other buildings served as the town's bank, including the I.O.O.F. Before the establishment of a permanent bank, the Allentown National Bank set up a temporary facility for the Cooper Cattle Sale. Wismer's store, formerly J. D. Knerr's, sits beside the bank with Wismer's barn showing in the rear and Mildred Musselman's home in the back right. (Coopersburg Historical Society, photograph by Mildred Musselman.)

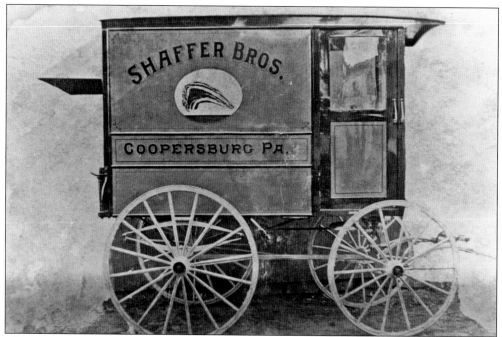

The Shaffer family was known for its high-quality meats. Four generations of Shaffers served the area as butchers, setting up shop in Allentown as well as Coopersburg. The business passed from Burton Shaffer to Arcus Shaffer, then Daniel Shaffer, and finally Ray Shaffer. Arcus Shaffer built the shop, which stood in John Alley in Coopersburg. As business decreased, Daniel Shaffer worked as a carpenter as well as a butcher.

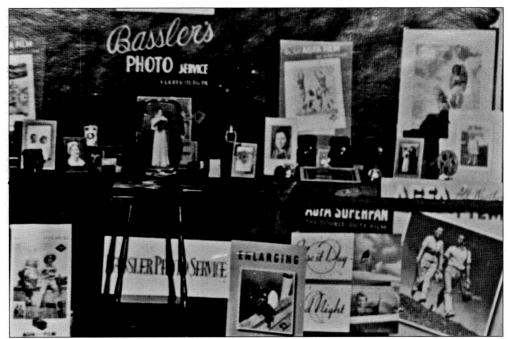

In 1935, the new town hall in Coopersburg became a venue for displaying the local wares. For a fee, local businesses set up booths to demonstrate their newest items. Visitors left with wish lists and souvenirs emblazoned with advertisements. Originally titled the Coopersburg Businessman's Show, it was renamed the Coopersburg Trade Show when a local beauty shop rented a space in the hall. Harvey Bassler's stand displays his photography business. (Donald Bassler.)

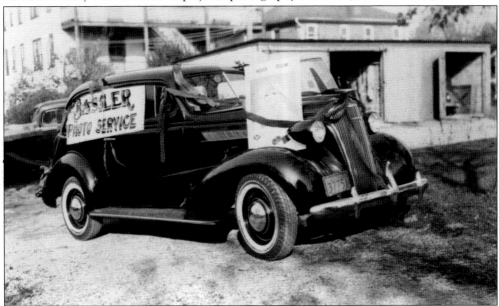

Harvey Bassler decorated his car to showcase his photography service, perhaps for a parade or the trade show. Bassler took many of the photographs in this book with high-quality German Agfa film and developed them into the photo postcards that were popular at the time. All of the aerial photographs used were taken by Bassler while he was learning to fly an airplane. (Donald Bassler.)

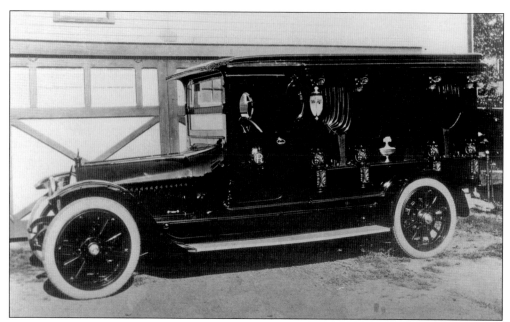

Henry Ritter began his funeral business with a horse-drawn hearse, but eventually he acquired this motorized Hudson Chassis hearse built by Peter Cooper in his garage at Linden Grove. The hearse later burned, leaving little to salvage. Ritter's grandson, Donald Bassler, preserved what he could and displays the remaining pieces of the vehicle in his garage today. (Donald Bassler.)

Henry Ritter served as the town undertaker for Coopersburg in the early 1900s, when funerals were held in the home of the deceased. In the late 1920s, he built a funeral parlor in his barn behind his home. After Ritter's death, the business continued, and in 1933, Bill Gruver acquired it. He and J. Harvey Baus moved the funeral parlor to the front of the house seen here. (Donald Bassler.)

The Ritter furniture store at 118 North Main Street in Coopersburg also made and sold burial caskets. Joel Ritter's son Henry started making the caskets in the rear of the furniture shop in 1902. While the store sold carpets and cabinets, Henry pursued the mortuary business and turned the casket making over to Harvey Baus in 1912. The furniture business was sold in 1921 to Cyrus Oberholtzer. (Donald Bassler.)

For nine years starting in 1942, the Coopersburg Home Fair dominated the area around town hall for its late-summer agricultural event. Displays of produce and canning like this were in abundance, and youths as well as adults were judged on their agricultural accomplishments. Competition was tough, and large circus-like tents outside heightened the excitement for the event. The event was originally intended to maintain an interest in farming. (Donald Bassler.)

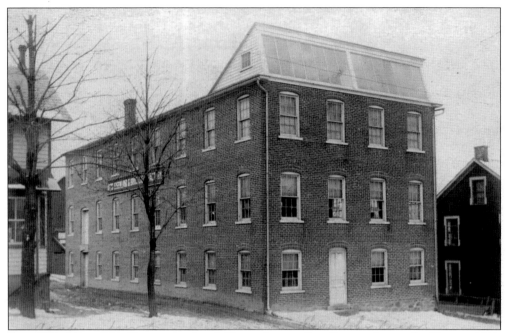

Eisenlahr's Zinco Cigar Factory employed 50 people at its East Station Avenue building in 1913. The tobacco arrived on local train cars that were then packed with finished cigars to be shipped out of town. Only handmade cigars left the factory until it closed in the mid-1920s, when it was leased to a sewing factory. Today the Saucon Creek Apartments fill the building.

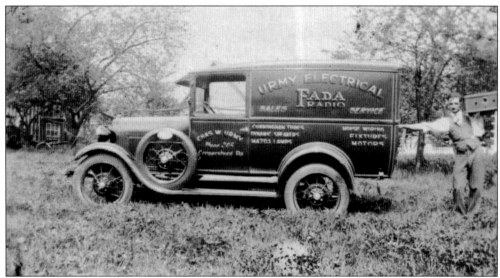

Charlie Urmy was the first electrician in Coopersburg in 1921. Shown standing by his truck, he sold various electrical appliances, including the Fada radio that he holds here. Thanks to the Lehigh Transit Company and its electric trolley lines, residents could tap into the electrical power running through town. However, the circuit was small, and southbound trolleys caused the power to dim or go out altogether as they pulled uphill. (Urmy family.)

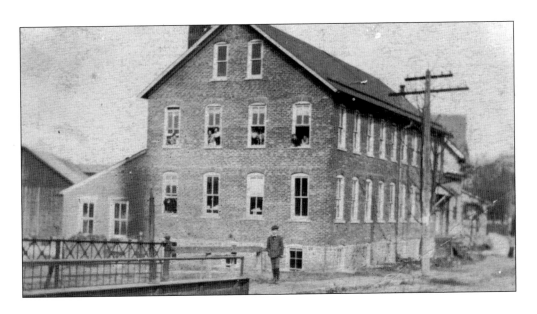

Women pause from working to peer out the window of the Gabriel Hosiery Mill factory (above). Approximately 125 employees worked at the mill, both male and female. The women who worked there earned $15–$20 and made 500 dozens of stockings each week. The business suffered when silk stockings came into style in the 1920s, and it closed in 1929. The hosiery mill is located on the left below, across the street from the dye house. Located between the dye house on the right and the building behind it is the first hand pump used before Coopersburg had a firehouse. (Above, Donald Bassler.)

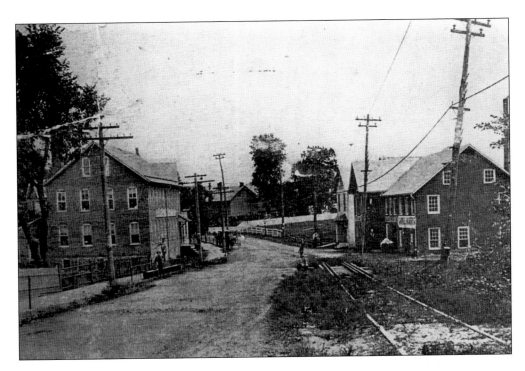

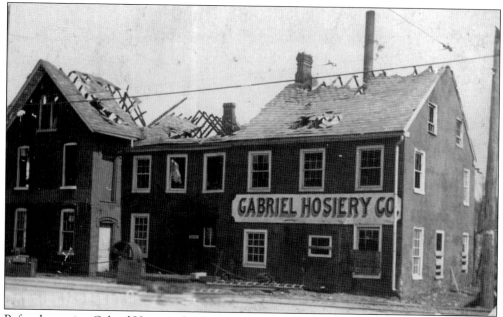

Before becoming Gabriel Hosiery, the dye house located at 22 North Main Street in Coopersburg was Jordan Carriage in the 1850s. In this picture, damage from an April 1909 fire can be seen. The hosiery eventually closed, and the buildings were again repurposed, with this one becoming the locker rooms and snack bar of the Blu Dov pool. The factory across the street is today's Saucon Creek Apartments.

This stamp and seal was used by Gabriel Hosiery in 1906. The factory opened when Milton S. Gabriel decided to expand his Allentown plant into Coopersburg. Here he made seamless cotton stockings dyed to color. (Donald Bassler.)

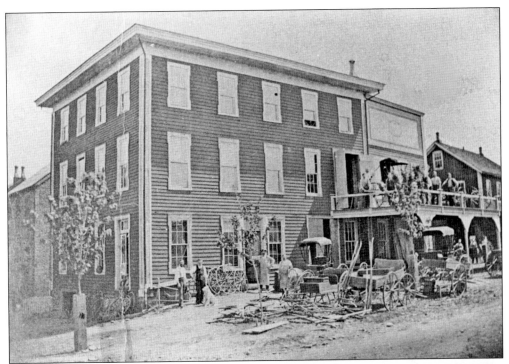

The Russell and Harvey Kern Carriage Works was located on the corner of Main Street and Station Avenue and, starting in 1865, custommade each carriage. They were built on the first floor then lifted by a manpowered elevator to the second floor for upholstering. Here a finished carriage sits on the second-floor ramp ready to be wheeled to the showroom. The carriage works burned on April 9, 1928.

Early local businesses advertised with handpainted signs and barn advertisements. Erwin G. Erney sold stone and sand from one of the quarries near Limeport. The limestone quarried in the township was often shipped to farms across the county that needed to add lime to their growing fields. (Jeff Donat.)

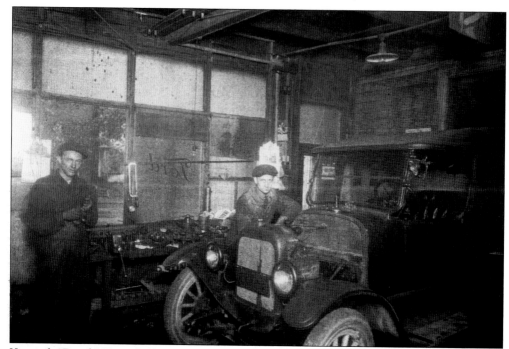

Kenneth "Dutch" Kern (left) works in his garage behind his home at 531 Station Avenue with Arcus Cooper. Kern was born in 1904, a year after the Franklin automobile was first produced, and he died while working in his garage on April 14, 1984. Known nationwide for his skills with the Franklin motor, Kern also served on Coopersburg's Democratic committee for 50 years.

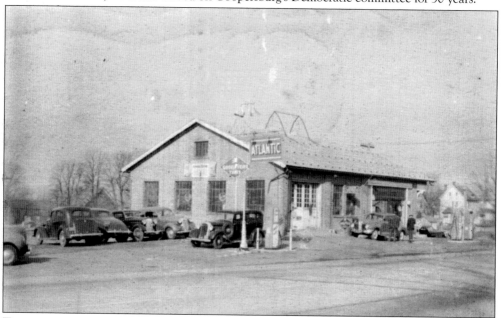

Transportation was an important business in Coopersburg. Paul Knerr and Ross Welsh's garage had enough frontage along Station Avenue and Third Street that it was spared during the repeated widening of Route 309. Thomas Troxell purchased the property after Knerr and Welsh and focused on antique automobiles. (Jeff Donat.)

Six

MILLS AND MINES

At one time, the township had abundant mills lining the creeks. The miller owned the rights to the creek leading up to his mill. Unfortunately, many of the mills were destroyed over the years. This photograph is labeled as the "ruins of the old mill." While it could be any of the mills in the township, it may be Saks Mill, which was also known as the Olde Mill. (Jeff Donat.)

Affectionately called Lovers Falls, the water ran freely after passing through Stopp's Mill, built by Joseph Fry Jr. A man with many interests, Fry served as the namesake of the town for 15 years before it was renamed Coopersburg on June 25, 1832. Fry operated a tavern, stood as a judge, served in the state's house of representatives, and sat in Congress from 1827 to 1830.

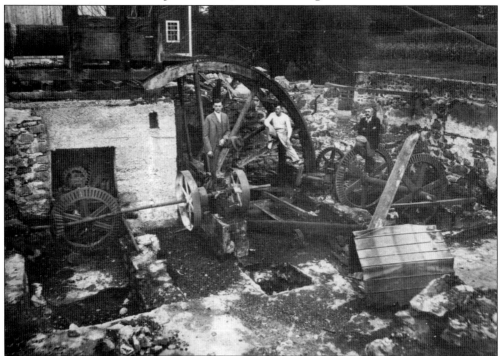

Known as Stopp's Mill, this mill was owned by the Stopps from Allentown, who leased it to various millers. The mill and its farm fell into disrepair after 1940 and were destroyed completely in 1956 for the housing development along the new West Fairmount Street. The original stones from the mill walls were used to fill in the low-lying swamp surrounding it. (Donald Bassler).

The original Young's Mill burned and was rebuilt with this waterwheel as the John Ritter Mill along Mill Road. Ritter abandoned the mill in 1919 or 1920, when it became a pants factory under new ownership. Years later, it became the private residence that it is today. (Donald Bassler.)

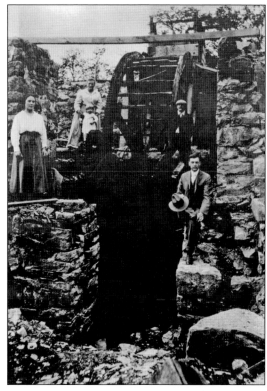

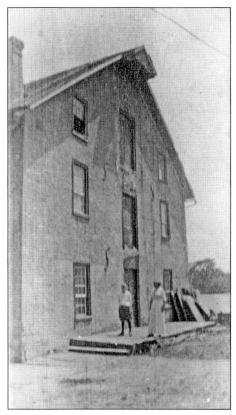

Though records are sketchy, Geisinger's Mill may have been the first mill in Lehigh County, with a record of operation in 1731. Until 1752, George Zevits owned the mill. On September 14, 1858, Enos Erdman and Jacob Geisinger purchased the rebuilt stone structure. Geisinger acquired full control of the mill in 1880, the approximate time of this photograph.

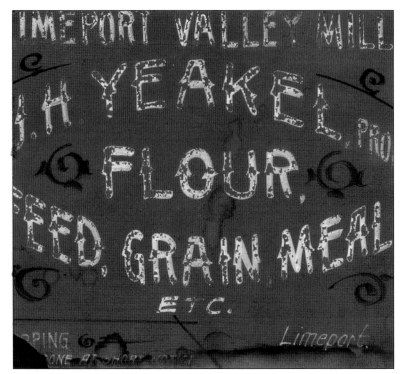

John H. Yeakel owned the mill along Limeport Pike known later as Zapach's Mill. Ted Zapach, active in preserving the history of the township, restored the barn on the mill property to reflect its original Ceresota Flour advertisement. For years, the barn showed a historic Mail Pouch Tobacco sign, but as it began to fade, the Ceresota advertisement could be seen beneath it. (Jeff Donat.)

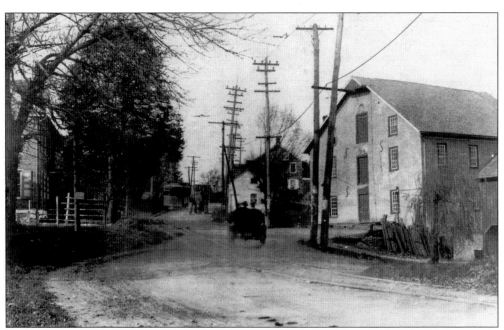

The Geisinger Flour and Feed Mill in Center Valley was one of the buildings destroyed in 1974 during the widening of Route 309. After its days as a mill were over, race car driver Eddie Saks converted it into a club known as the Olde Mill, but locals called it Saks Mill. After Saks's death in 1964, it was another club known as the Mod Mill.

The hoist house of the Friedensville mine (above) is under construction on November 22, 1950. By January 25, 1951, the interior is beginning to show the most modern mining advances (below). The hoists lifted 65-man, double-deck service cages and two skips that could each carry six tons of ore. Early mines were more basic, with open pits and hand straining of the minerals. The first mines in the township were the Ueberroth, Old Hartman, New Hartman, Triangle, and Correll mines. The Ueberroth mine began in 1853 and closed due to water saturation in 1893. The New Hartman mine opened in 1879 and closed in 1892. These two mines were in the same location as the Friedensville mine here. (Both, Mayo Lanning.)

The water tank for the New Jersey Zinc Company offices is shown under construction on February 21, 1951. When the company began to once again mine on the original Jacob Ueberroth farm in 1948, only a few wooden planks and a cleared area in the middle of a farm field marked the beginning of a large mining operation. Mining in the area along Saucon Valley Road had been underway for almost 100 years before the New Jersey Zinc Company took over. (Both, Mayo Lanning, photographs by New Jersey Zinc.)

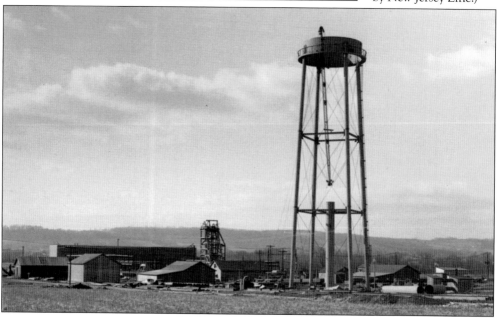

Executives of the E. J. Longyear Company, the company responsible for removing water from the Hartman mine shaft, pose outside the Friedensville mine. From left to right, they are (first row) Frank "Killer" Kane (superintendant) and two unidentified executives; (second row) Arvo "Snowshoe" Warim (a master mechanic), Oscar Pirilo (shift foreman), Mayo Lanning (shaft engineer), and R. Loofborrow (district supervisor). (Mayo Lanning.)

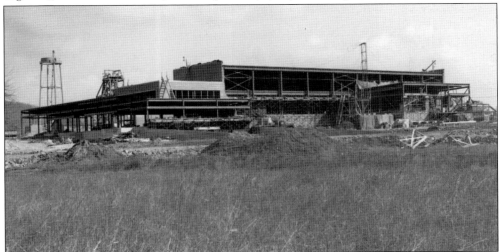

On February 21, 1951, the office and hoist house for the New Jersey Zinc Company's mine in Friedensville was nearing completion. When the company began pumping water from the shafts, it was the second largest industrial user of Pennsylvania Power and Light electrical power behind Bethlehem Steel, and all of the power was used to operate the pumps alone. In the 1950s, the company's electric bill exceeded $1,000 a day. (Mayo Lanning.)

E. J. Longyear Company master carpenter Roy Kavisto (left) looks at the form for the main mine shaft at Friedensville on May 15, 1952. Years before, the zinc was discovered when Jacob Ueberroth tried to burn limestone to create lime ash for his crops. While everyone else burned their limestone into fine powder, Ueberroth ended up with a mysterious mass. He later learned that his limestone was laced with zinc. (Mayo Lanning, photograph by New Jersey Zinc.)

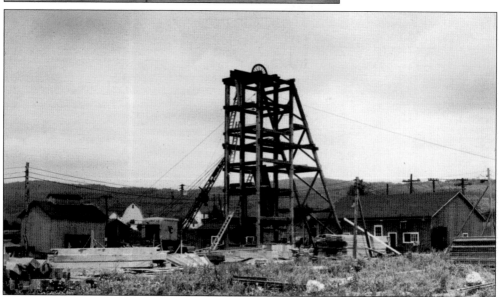

On June 1, 1948, the head frame for the Friedensville mine was under construction beside the main mine shaft. Upon its completion, the frame was shifted over the shaft because it was too dangerous to construct the headframe on the open shaft while men worked below. The finished head frame was 134 feet high and weighed 200 tons. It was completed on Thursday, October 30, 1952. (Mayo Lanning, photograph by New Jersey Zinc.)

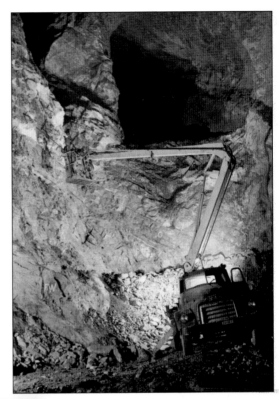

Mining at Friedensville was done by the New Jersey Zinc Company from 1956 through 1983. From 1948 to 1956, the plan for water removal was carried out, and ore production began in 1958. The main entrance shaft, with its large headframe, was at the mine headquarters off Camp Meeting Road, and a second entrance closer to Lehigh Mountain allowed vehicles to drive into the mine. The mine was dug in room-and-pillar style, allowing these large machines to work efficiently within each room. These men are part of the mine scaling crew, and the workers called these machines "giraffes" because of their ability to reach the upper walls of the mine. (Both, Mayo Lanning, photographs by New Jersey Zinc.)

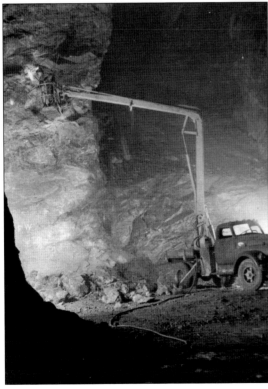

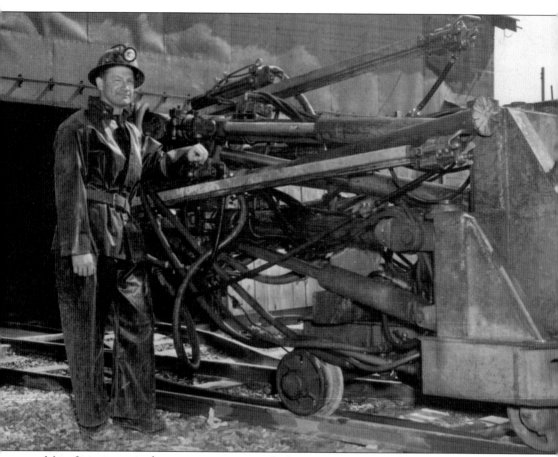

Mayo Lanning served as a mine engineer with the New Jersey Zinc Company from 1950 to 1966. He left at that time to pursue a teaching career at Moravian College after receiving his doctorate from Lehigh University. Lanning poses in 1953 by a drilling jumbo. His main focus was on the rising water in the mine and pumping it from the depths. Water has always been a problem in the mine. Its original mining stopped from 1869 to 1872 so the "President," the largest Cornish pump in the world, which could raise 17,000 gallons of water 220 feet in one minute, could be installed. Weighing 667 tons, it began pumping on January 20, 1872. Legend says that Pres. Ulysses S. Grant was to start the pump, though no recorded arrangements were made for his arrival that day. (Mayo Lanning, photograph by New Jersey Zinc.)

This picture taken on March 23, 1951, at 700 feet deep, shows holes and inserts used to test the ground for rising water levels at the Friedensville mine. In the original Ueberroth mine, the President pump was installed to pump enormous amounts of water from its depths. The pump operated for three years. Eventually, the miners reached a depth where the water took over, and the mine was closed. (Mayo Lanning.)

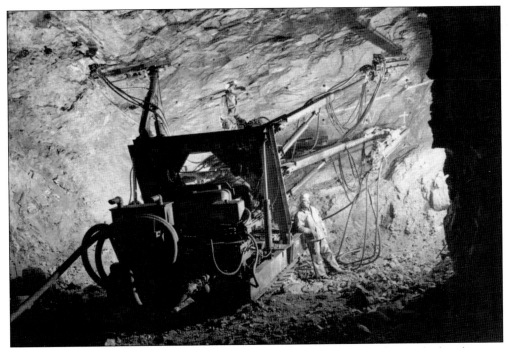

These "jumbos" dug the shafts for pumping water from the mine. Trucks that worked in the mine started out on underground railroad tracks, which evolved into the caterpillar-style treads (seen here). These wheels wore out quickly on the rock surface, and rubber tires were then used on all of the trucks. The zinc ore in the Friedensville mine was discovered by Andrew K. Wittman on the Ueberroth farm in 1845. Five years later, 17,000 tons of zinc was mined each year from the mine. (Mayo Lanning, photograph by New Jersey Zinc.)

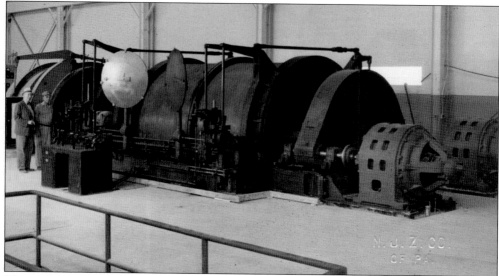

The ore hoist for the Friedensville mine was installed on August 22, 1951. So much water filled the original mines that Lake Thomas, a beloved lake resort, grew from a filled open mine known as the Morey Mine sometime around 1884. Cottages were built along the lake with no stream feed. As water tables dropped with the new pumping in the 1950s and again when the mine was abandoned, the lake all but disappeared. (Mayo Lanning, photograph by New Jersey Zinc.)

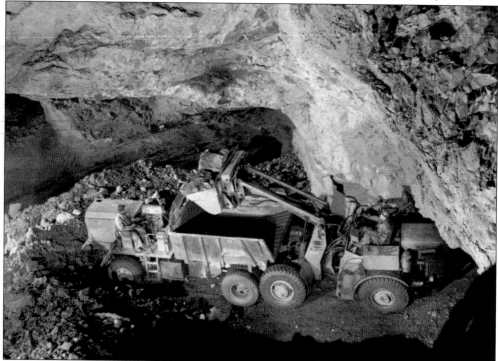

The average employment of the Friedensville mine was 190 people. The work was often wet due to the high water concentration in the mine. This loading crew will drive the zinc out of the mine to Palmerton for smelting. The original Hartman and Ueberroth mines shipped the zinc to Bethlehem for zinc oxide production. (Mayo Lanning, photograph by New Jersey Zinc.)

Seven

CATTLE COUNTRY

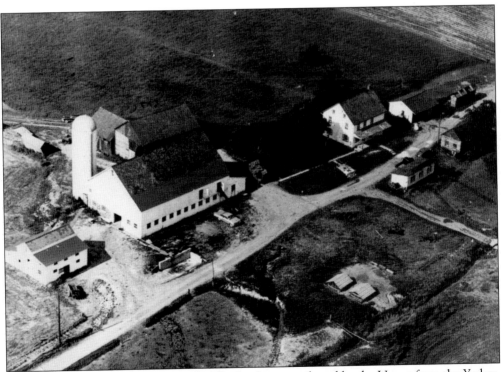

The Urmy farm is shown here in 1960. The land was purchased by the Urmys from the Yoders, who purchased the land from William Penn. The family continuously raised Brown Swiss cows in addition to Holsteins. During the 1950s, the Lehigh County Extension Service consistently listed this herd in the top five of the monthly Dairy Herd Improvement Association. (Urmy family.)

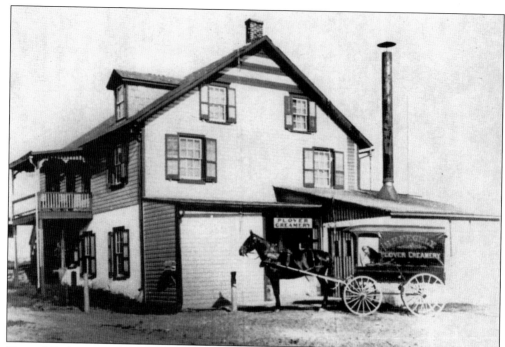

Howard Fegley owned and operated Fegley's Dairy in Limeport as well as the Plover Creamery, seen here. He also built the Limeport Stadium. A known family man, Fegley is said to have built the stadium for his two sons, Homer and Russell, who played baseball. The meeting- and trophy house that sits in the stadium parking lot used to be Fegley's personal garage. (Clifford Benner.)

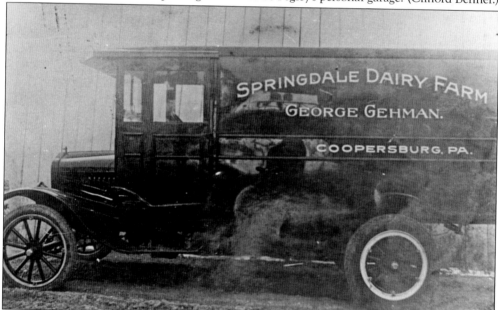

Many businessmen had delivery routes for their products; dairy farmers were no different. One dairy farm owned by George and Grace Gehman bottled milk for local delivery. Springdale Dairy Farm was located on Jacoby Road near Tumblebrook Golf Course, where Gehman would load his delivery truck. Gehman delivered the fresh milk daily along his route through the township.

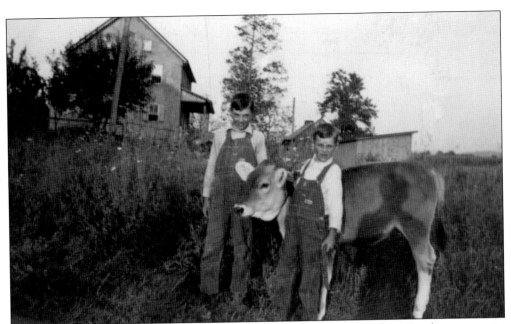

Ralph Urmy (right) remembers the calm life growing up on his family's farm. Sundays were quiet and spent with family, and he remembers his mother posing the children for photographs on Sunday afternoons. Here he and his older brother William pose with one of the Brown Swiss calves in the pasture beside the house. (Urmy family.)

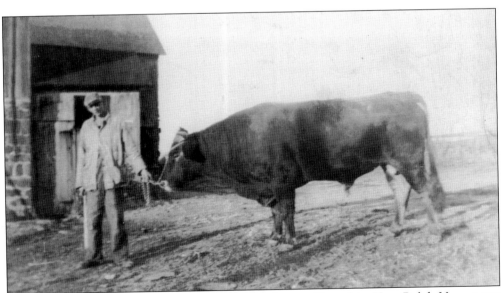

Agriculture has always been important in Upper Saucon Township. Here Ralph Urmy poses with a bull. The first 4-H animal that he raised was a Brown Swiss cow named Eva. The Urmy family annually showed and won prizes for their cows at the Allentown Fair as well as at the state competition in Harrisburg. (Urmy family.)

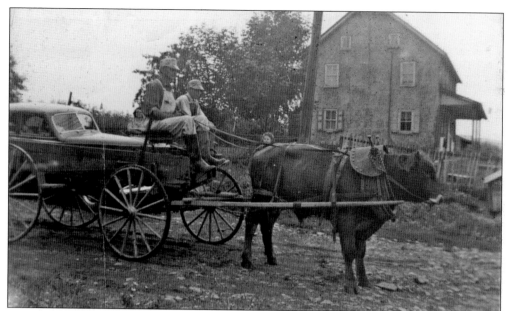

Marvin Urmy takes his son Ralph for a ride in a family wagon pulled by one of the bulls on the farm. Taking the extra time to hitch one of the farm bulls to a wagon shows how laid back life was during those days. This was not the only time that the bull pulled the wagon; he was a regular lead. (Urmy family.)

Marvin Urmy (left) and his son Ralph hitched their bull to the sleigh during a winter snow one year. They are stopped in front of the first house built along New Street in Center Valley on their way to their farm. Marvin and his brother Floyd operated the farm after their father, William, retired from farming. (Urmy family.)

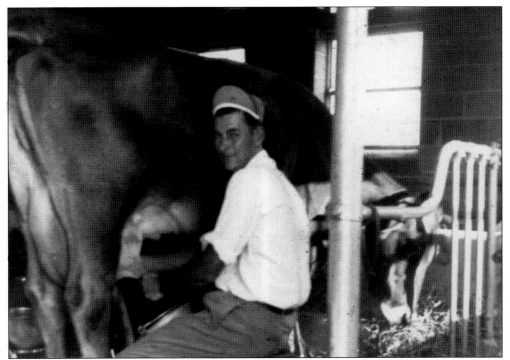

Before milking machines appeared in dairy barns, milking was done by hand. Ralph Urmy milks one of his cows, a task done twice a day on a dairy farm. Dairy farms like this delivered their milk along routes or left it on tables along the train and trolley routes for pick up. There were so many dairies that Center Valley was nicknamed "Milk Town." (Urmy family.)

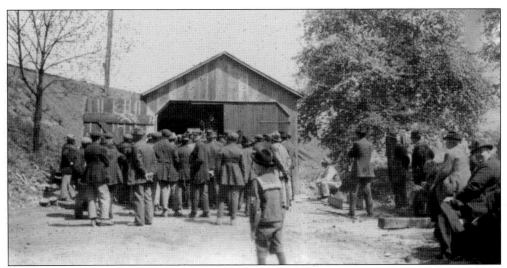

A sale in a Center Valley barn attracts quite a bit of attention in 1920. Compared to the Cooper Cattle Sale, this crowd is small. The larger annual sale attracted enough people that the Allentown police force sent officers to protect people carrying large sums of money for the day of the sale. Besides his annual Coopersburg sale, Tilghman Cooper traveled to sell his cows as far as New Zealand.

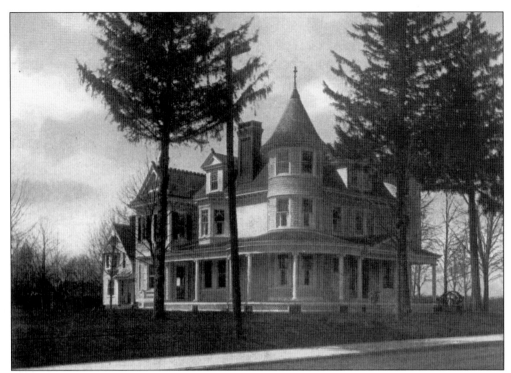

Linden Grove (above) was home to the Coopers, who sold Jersey cattle worldwide. Peter Cooper was born in the home, which was built in 1840. After the Cooper cattle business ended, the property was sold in 1937 to the Sacred Heart Church and operated as an orphanage. Hundreds of children passed through the dormitories built behind the home even after a fire ripped through the girls' dormitory in 1939. When the orphanage closed in 1974, the land served as Pinegrove Junior College for several years before being abandoned. Restoration has begun on the property once again. Across from the Cooper house at Linden Grove sits the Linden Pavilion (below). The long building in the rear is the carriage house, and the milk house sits to the left.

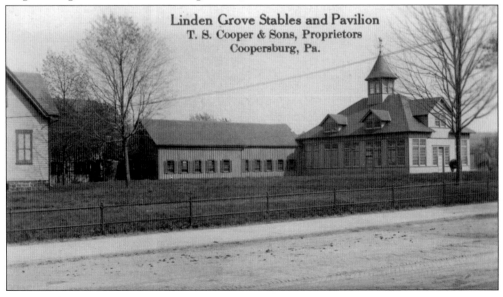

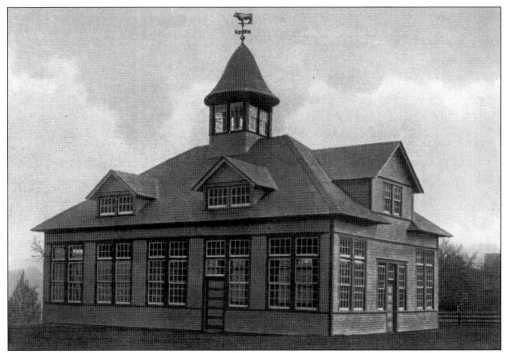

Across from his home on Main Street sat Tilghman Cooper's exercise and sale pavilion, used for cattle sales on rainy days. On top of the building, a copper and cast iron weather vane in the shape of a bull can be seen. The vane received annual polishing and repairs in time for the Decoration Day sales. When the sale pavilion was sold to Fred and Margaret Pennewell, they removed the bull from its perch and preserved it as a reminder of the days of Cooper cattle. In 1976, it was brought out for display, and today it remains on display in the Coopersburg Historical Society Museum on the second floor of the town hall (below). (Photograph below by Kelly Ann Butterbaugh.)

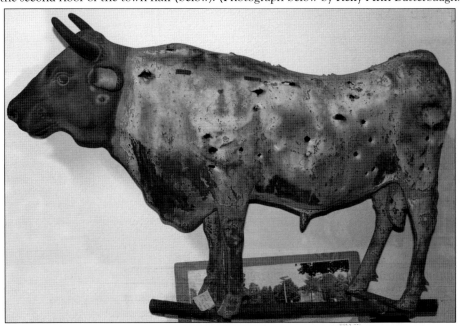

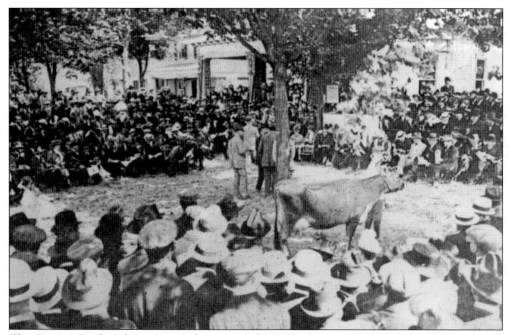

The Cooper Cattle Sale in Coopersburg was held on the lawn at Linden Grove on Decoration Day. Here the cattle were paraded and auctioned. All businesses closed that day, and nearly 5,000 people dressed in their finest clothes crowded town for the sale. Train cars arrived, parked, and provided service for impressive visitors such as the Vanderbilts and the Rockefellers. The town's hotels could not offer the luxurious service these clients expected.

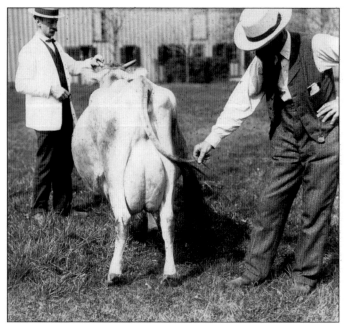

On May 20, 1911, Tilghman S. Cooper (left) posed with his Jersey cow Emerits Safety. Cooper is said to have posed with each of his cows for known animal photographer Henry A. Strohmeyer. He then created annual catalogs of the animals and their statistics. One Cooper bull won sweepstakes at the World's Fair in Chicago, and another bull won the grand championship at the National Dairy Show in Chicago in 1911. (Coopersburg Historical Society, photograph by Strohmeyer.)

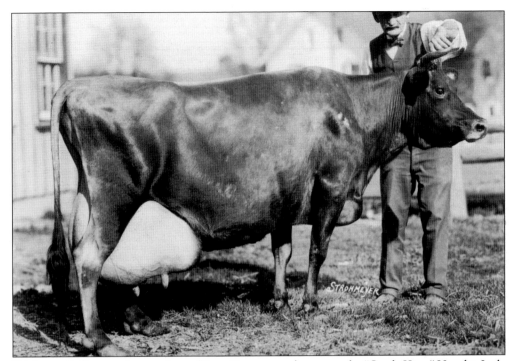

Tilghman S. Cooper, the grandson of Peter Cooper, was known as the "Cattle King." Here his Lady Plymouth is posed. He began breeding Jersey cows after researching the breed, which produces more butterfat than other breeds. His first cow sale was in 1874 at Madison Square Garden in New York City. In 1900, he began the annual Cooper Cattle Sales at Linden Grove in Coopersburg. (Coopersburg Historical Society, photograph by Strohmeyer.)

This bull, named Son of Victor, was sent to New Zealand on May 1, 1928, and sold there for $2,550. Tilghman Cooper made his last cow sale in New Zealand on Saturday, September 8, the same year. There he grew ill and died on September 27, 1928. The cows at Linden Farms continued to be sold, with the last sale occurring in 1931.

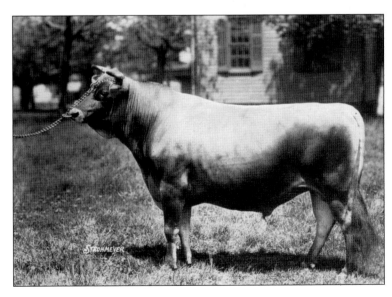

BIBLIOGRAPHY

Associated Press. "Coopersburg Blast Kills 5." *Delaware County Daily Times*. February 22, 1973.
———. "Gas Odor Back in Coopersburg." *The Valley Independent Monessen*. February 22, 1973.

Bicentennial Committee. *Upper Saucon Township: A Bicentennial Tribute 1743–1976*. Upper Saucon Township, PA: Upper Saucon Township, 1976.

Borger, Evelyn. *Coopersburg: the Town of Possibilities*. Coopersburg, PA: Chernay Printing, 1979.

"Kenneth 'Dutch' Kern, 81; Was Renowned Franklin Car Specialist, Noted Area Musician for 49 Years." *Sunday Call-Chronicle*. April 15, 1984: B24.

Ohl, Albert. *History of Southern Lehigh County Pennsylvania, 1732–1947: Also Centre Valley, Pa as I Found It 75 Years Ago*. Coopersburg, PA: Lions Club of Coopersburg, 1952.

Reinik, Ruby Young. *A History of St. Paul's Lutheran (Blue) Church*. Coopersburg, PA: St. Paul's Lutheran (Blue) Church, 1992.

A Sister of the Community (Sister Mary Elisabeth of the Trinity). *Mother Therese and the Carmel of Allentown*. Philadelphia: Jefferies and Manz, 1949.

Whelan, Frank. "Center Valley's Bridge Helped Milk Get to Market." *The Morning Call*. April 12, 1992.